SECRET LLANDUDNO

JOHN LAWSON-REAY

AMBERLEY

Llandudno, my love.

First published 2017

Amberley Publishing
The Hill, Stroud
Gloucestershire, GL5 4EP

www.amberley-books.com

Copyright © John Lawson-Reay, 2017

The right of John Lawson-Reay to be identified as the
Author of this work has been asserted in accordance
with the Copyrights, Designs and Patents Act 1988.

ISBN 978 1 4456 7044 7 (print)
ISBN 978 14456 7045 4 (ebook)

British Library Cataloguing in Publication Data.
A catalogue record for this book is available from the
British Library.

Origination by Amberley Publishing.
Printed in Great Britain.

Contents

Acknowledgements

Firstly thanks to my wife Barbara for her interest and support.

Christopher Draper for *Llandudno Before the Hotels* and the late Ivor Wynne-Jones for *Llandudno Queen of Welsh Resorts* – for me the bibles of Llandudno history. Back in the 1960s I did contribute in a small way to Ivor's first edition and later editions of LQWR.

Adrian Hughes of the Llandudno Home Front Museum for his expert military advice and Sue Ellis, staff and volunteers at Conwy Archives for their cheerful, professional assistance.

Introduction

I am very much aware that I am standing on the shoulders of historians who have gone before. For the story of the life of the people who have inhabited this area since the last Ice Age, I would highly recommend Christopher Draper's book *Llandudno Before the Hotels*. He explains how Llandudno, properly known as the Creuddyn Peninsula, was for thousands of years a remote outpost from civilisation. There was copper mining activity on the Great Orme during the Bronze Age, but it returned to being a backwater until the industrial mining of copper in the eighteenth century. Back then, the only realistic way of getting here was by sea. Flat-bottomed sailing vessels would come to the beach and wait for the tide to leave them high and dry. They could then unload supplies for the mines and groceries for the community, before taking away the copper ore to Swansea for smelting.

My maternal grandparents, who were born in the 1880s, saw Llandudno – which was still being built – as a new town without any history. They were actually part of a new history being made around them. My great-grandfather, Owen Thomas, was a plumbing contractor with a profitable business, as all the new buildings needed the most up-to-date plumbing, such as indoor toilets, baths and running hot water. What luxury!

I am most interested in the past 150 years or so, where we have much written evidence to work on. The most fertile place for information is the local newspapers, but there is no doubt that the internet revolution has been a major boon for researchers, with much historical information now available online. My feeling is that anecdotes bring history to life. The well-documented goings-on of the high and the mighty remain removed from the lives of ordinary people.

I take great pleasure in the fact that my wife Barbara and I live in one of the Mostyn-built houses. It is around 120 years old, built in the mock-Tudor style that was all the rage back then. It was built with two others, for employees of Bodysgallen Hall, which was owned by the Mostyn family.

There have been several descriptions of the town used by publicists; 'The Queen of Welsh Resorts' or the 'Naples of the North' are the best known and well deserved – ask any visitor to the town!

1. Around the Coast

The *Sisters' Memorial*

Before the arrival of steam vessels, sailing crafts were very much at the mercy of the weather and tides, and thousands of seamen died every year. Many losses happened within sight of the shore and there was a desperate need for something to be done.

The Royal National Lifeboat Institution (RNLI) was formed in 1824 and granted a Royal Charter in 1860. It was funded by legacies and donations, with most lifeboat crewmembers being unpaid volunteers. There are now 237 lifeboat stations around the country and 444 lifeboats. The RNLI also has lifeguards operating on 200 beaches.

In 1859 local Llandudno worthies wrote to the Institute asking for a lifeboat. The Hon. William Lloyd Mostyn offered a site for a lifeboat house beside the railway station.

A 32-ft, ten-oared, self-righting boat was sent by rail to Llandudno, arriving on 11 January 1861. It was a gift from two sisters, the Misses Brown from Toxteth, Liverpool – they had been regular visitors to Llandudno during their childhood years, together with their deceased older sister, and the lifeboat was named in her memory.

When needed at other towns along the coast, it was intended to transport the boat by the same means that it had arrived – by rail, but there is no record of this ever having happened. A team of horses was needed to take the boat to the beach and launch it with a system of pulleys anchored out in the bay. The lifeboat station did not have its own horses and when an emergency arose they would acquire them on loan from local carriage and cab operators – there were plenty around at that time.

Lady Augusta Mostyn smashed a bottle of wine on the lifeboat's stern and named her the *Sisters' Memorial* – the first lifeboat to be given a name. Naming a lifeboat after a person – usually deceased, with the family paying for it – continues to this day.

The lifeboat station was known as 'The Ormeshead' and the first coxswain was Hugh Jones, a copper miner and local fisherman. It is said that his daughter banged on the top of the mineshaft to let him know when he was needed to man the lifeboat.

In 1887, a few days after the inauguration of a new lifeboat – the *Sunlight No.1* – Edward Jones, the second coxswain, died from a chill.

In 1890 the crew mutinied because they believed that the coxswain, Richard Jones, was drunk. A local doctor climbed onto the launching carriage to appeal for volunteers at the same time as ordering the coxswain off the boat. During the subsequent launch, a man named Robert Williams, who was helping to manhandle the boat across the beach, slipped beneath the carriage and was killed. A fund was set up locally for his dependents and the RNLI donated £100 – about £6,000 today.

In 1892 a similar accident occurred and a man named Arthur Whaley suffered the same fate.

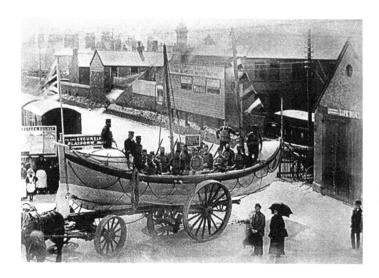

An artist's impression of the *Sisters' Memorial* lifeboat being launched in Llandudno Bay, going to the rescue of a ship in distress.

The fourth casualty was actually a lifeboatman, John Williams, the second coxswain – he died from exposure while out on service in Conwy Bay in 1908. Another member of the crew, Evan Evans, lay injured and unconscious for several hours during this same launch but survived.

DID YOU KNOW?

In 1903, after the new lifeboat station was built in Lloyd Street, the old premises beside the first railway station were demolished to make way for the new headquarters of the Llandudno Unit of the Royal Naval Artillery Volunteer Reserve. It was built as a replica of part of the gun deck of HMS *Majestic* with gun ports and a practice cannon. The *Majestic* had served in the Crimean War and in 1860 was posted to Liverpool to serve as a coastguard warship in the Irish Sea.

The Semaphore Station

One of the very few attractions for Llandudno's visitors in the nineteenth century was the summit of the Great Orme. Here, at 670 ft above sea level, was a semaphore station established by the Mersey Docks and Harbour Board in 1826. It was part of a chain of a twelve relay stations to communicate information about shipping movements from Holyhead to the port of Liverpool. The main purpose was to report to the city's merchants who were waiting for their sailing ships, so they could make arrangements for docking and unloading at the port. The ships would pass a message, using flags, to the first station on Holyhead Mountain, then the semaphore system could pass this on to Liverpool.

In 1827 the first signal was passed along the 75½-mile-long line, informing Liverpool that the wind had changed direction at Holyhead, from southwest to west. The message

took just five minutes to reach its destination. A Liverpool newspaper dubbed this as 'Faster than the Wind' as it took a full hour for the wind change to be detected in Liverpool. The system used code books so that they did not have to spell out each message.

By 1836 the original wooden building was in a state of decay, so work was started on a new station with dwelling houses for two keepers, signal room, outhouses and a new flagstaff. This was completed in 1841. The most well-known keeper was Mr Job Jones, who had served at the Llysfaen Station in 1839 but moved to the Great Orme Station in 1842. A contemporary report tells us that:

> Mr Jones is remarkably courteous and intelligent; not only affording ready information to every inquirer, but kindly permitting visitors to watch his telegraphic operations, which at convenient opportunities he is always willing to explain; and to take a peep through his powerful telescope at the sublime scenery of the district. A book is kept in which visitors are expected to enter their names and addresses. Strangers notice than the domestic comfort and cleanliness of his dwelling, which are most creditable to the industrious management of his wife and family; every one of whom are skilled in the use of the telegraph. A sheltered nook on the side of the hill near the station is a favourite resort with picnic parties, combining as it does, welcome facilities for the enjoyment of the glorious prospects, and of the exhilarating recreations usually characteristic of such festive occasions. And here it might be proper to observe, that for the accommodation of visitors, Mr and Mrs Jones have set apart a comfortable furnished room, where tea is provided on the shortest notice and a supply of good lemonade, soda water and other beverages of the temperance class is always to be had. (John Hicklin's *Illustrated Hand-Book of Llandudno*)

The Jones's visitor's book still survives and informs us that over 2,000 people had visited the station in the fifteen years up to 1860, when an electric telegraph line was laid from Holyhead to Hilbre on the Wirral. Job Jones moved with his family to become a lighthouse keeper at Llandudno lighthouse, where he served till at least 1877. He died at the age of 88.

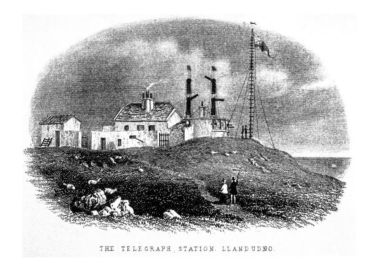

A popular attraction for visitors who climbed the Great Orme was the semaphore signalling station on the summit.

THE TELEGRAPH STATION. LLANDUDNO.

The semaphore station became the Telegraph Beerhouse, then later a temporary clubhouse for the new 18-hole golf course. In 1909 the clubhouse was demolished and the nine-bedroom Telegraph Hotel was built.

DID YOU KNOW?

It was on 10 August 1910 that thirty-four-year-old actor and pioneer aviator Robert Loraine landed his Farman Biplane on the golf course in Penrhyn Bay. This was the very first aircraft to land in Wales. He had taken off from a Blackpool Airshow using the pseudonym Jones to confuse his rivals, intending to fly along the coast to Anglesey as his hopping-off point to cross the Irish Sea to Dublin, and thus gain the overseas flying record of 63 miles. He came down in the sea at Howth Head near Dublin.

The Lighthouse

In 1862 Llandudno lighthouse was erected on the Great Orme for the Mersey Docks and Harbour Board, to the plans of George Fosbery Lyster, their Chief Engineer. The first keeper was Job Jones, who had moved down from the summit signalling station. The lighthouse was taken over by Trinity House in 1873. Throughout its life it used the original lantern, which had been made especially for it. Illumination was by a paraffin lamp with a wick until 1904, when a vapourised petroleum lamp with a mantle was introduced. This was replaced in 1923 with an acetylene mantle lamp which was used until electrification took place in 1965, with a 190,000 candle-power lamp.

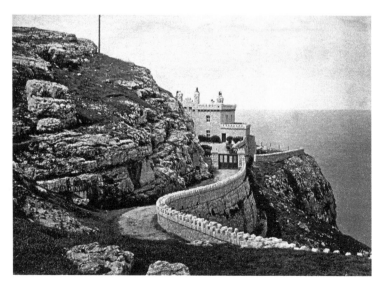

Llandudno's lighthouse is situated 325 ft above sea level. It was built by the Mersey Docks and Harbour Board to assist navigation along the North Wales coast.

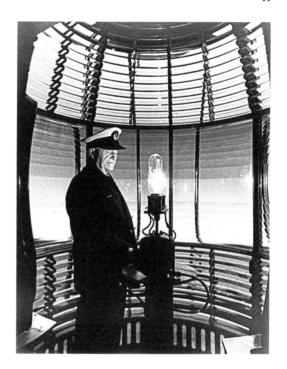

Last but one lighthouse keeper Percy Vaughan, with the lamp which had just been converted from gas to electricity in 1968.

Situated 325 ft above sea level, the keeper, his deputy and both their families lived in the building, which was split with a central hallway so that each family could have their own privacy. The wooden-clad hallway still exists. The lighthouse had an electric telegraph room which was in use until 1924. This replaced the old semaphore link which had been situated on the Great Orme summit. A radio location beacon was installed in the 1950s to assist the Harbour Board's vessels in the maintenance of their navigational buoys.

The end came in 1985 when the light was finally switched off and the station de-commissioned. The lantern was removed and initially taken to Liverpool to be displayed in the foyer of the Mersey Docks and Harbour Board's Office. As the lighthouse is a listed building, it was pointed out that the lantern had been illegally removed. In 1993 it was returned to Llandudno and can now be seen in the Visitor Centre on the Great Orme summit.

The lighthouse was eventually sold and is now open to guests for bed and breakfast.

Cust's Path and Marine Drive

Custs Path, encircling the Great Orme, was constructed in 1856–58 on the instructions of Reginald Cust, a Mostyn Estate's trustee. A penny toll was charged for its upkeep. When in 1868 Prime Minister Gladstone came to visit the Liddell family he was taken for a walk along it, but he was so terrified that he had to be blindfolded and led to safety! After that iron railings were installed at the most dangerous points and it became popular with Victorian visitors, who dressed up in their finery to walk along it and view the wonderful sunsets over Anglesey.

Above: Cust's Path, which encircled the Great Orme, was popular with Victorian visitors who came to see the spectacular views of Conwy Bay and Anglesey.

Left: Victorian ladies would dress up in their finery to walk along Cust's Path, just to watch the sunset.

In 1872 the Great Orme's Head Marine Drive Company Ltd was formed to convert Cust's Path into the roadway it is today. There were problems with getting capital funding so it wasn't until 1875 that the first sod was cut. Lady Augusta Mostyn fully backed the project and became a major shareholder. Quarrying in the Happy Valley had by this time ended, so the workforce to build the drive was available from redundant quarrymen and copper miners. The cost was about £10,000, which included the handsome tollgates at each end, and the road was completed in 1878.

The newly formed Llandudno Urban District Council bought Marine Drive for £10,500 in 1897. With its magnificent views it quickly became a notable and popular feature of the town. Tolls were modest and the penny toll for pedestrians was finally abolished in 1910.

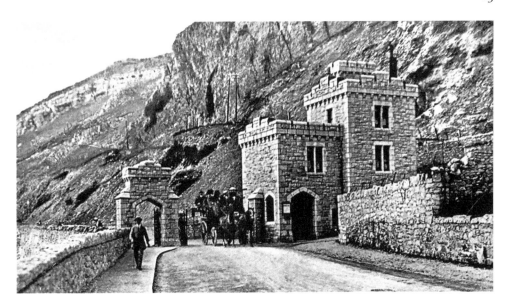

The West Shore tollgate.

Three Piers

Along with Blackpool, Llandudno has had three piers and nearly had four. The first was the result of the efforts of a group of entrepreneurs who formed the St George's Harbour Company in 1836. They intended to turn Llandudno into a harbour by means of a breakwater across the bay, to serve as a ferry and terminal for London–Dublin traffic. They presented a Bill to Parliament, which was debated and defeated.

It seemed that Llandudno had escaped being named St George and turned into a busy commercial port. Then, in 1853, the St George's Harbour and Railway Company re-emerged with an Act of Parliament authorising them to build a 3.5-mile branch line from a new Llandudno Junction station to Llandudno. The plan included a harbour with breakwater, lighthouses, piers, docks, locks, quays, wharves, landing places and all the paraphernalia of a port.

They built the railway line, but it seems that they were not able to raise sufficient money from investors for their grand scheme, so in 1858 they built a modest wooden pier to preserve their Parliamentary rights – which were subject to a time limit. The pier's entrance was quite near the old entrance to our existing pier.

The original pier was 242 ft long, 16.5 ft wide and 30 ft above the beach. It was not much use for the steamers as it was only useable at high water, but it was provided with benches for visitors to sit on. Only a year after the pier was built a massive storm seriously damaged it at the shore end. It was quickly repaired and continued in its limited use for the next eighteen years.

In 1875 a new Llandudno Pier Company obtained an Act which enabled them to build the present structure, and the old pier became of real use as the landing stage for the components for the new pier. The first pile was driven in July 1876 and the ironwork was brought from the Elmbank Foundry, Glasgow, by sea. The new pier was actually built over

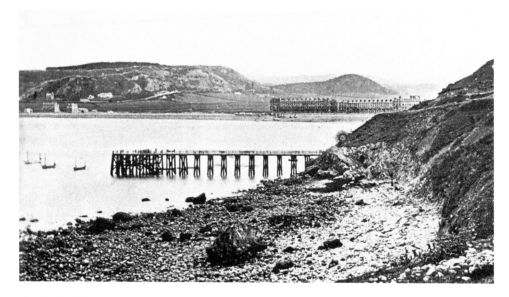

Llandudno's first pier, built in 1858.

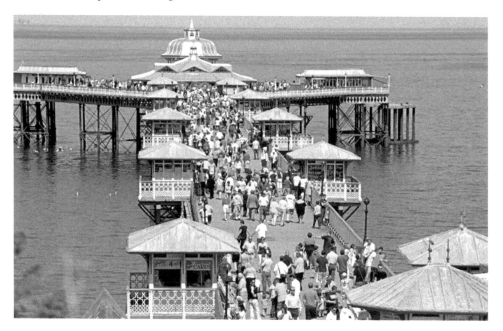

The second pier at Llandudno is still popular today.

the old pier, which was demolished when the new pier was completed, and opened to the public in 1877. Some remnants of the old pier can be seen supporting the porch of the Cottage Loaf public house in Market Street. The straight section of the new pier was 1,200 ft long – making it the longest in Wales. The spur and extension round the front of the Grand Hotel (at that time the Baths Hotel) was added in 1884 and a new landing stage in 1891.

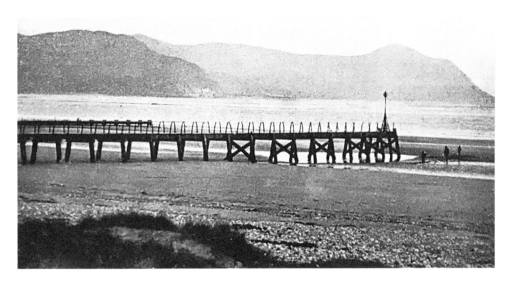

Llandudno's third pier, at the West Shore, had only a short life.

The third pier was on the West Shore near the end of Gloddaeth Avenue. In 1897 the Llandudno & Trefriw Steamship Company was formed to take advantage of the rapid growth of Llandudno, by opening up a water route from the West Shore to Trefriw. A new pier was built – 360 ft long, fairly narrow, piled structure – and was variously referred to as the West Shore Pier or Llandudno West Shore Jetty. A suitable paddle steamer was acquired and named *Queen of the Conway*, with a passenger capacity of 257. Her inaugural trip was made in May 1899. Thereafter the number of passengers embarking was extremely encouraging to the company, who thought they had discovered a goldmine, but it was not to last. Before the season had really got under way the Board of Trade intervened and pointed out that their passenger certificate only allowed them to operate within 'smooth waters' and that limit was set much closer to Deganwy than their new pier. This turned out to be an expensive blunder as the company was banned from operating except from Deganwy. The pier remained unused and was eventually swept away by the sea.

The fourth 'pier' was just a proposal to be built in the centre of Llandudo Bay, opposite Riviere's Concert Hall, later the Arcadia and now Venue Cymru. It was to be called the Victoria Pier with a concert hall at the shore end – much like the one in Colwyn Bay, but it was never built.

The *Flying Foam*

The last schooner to be wrecked in Conwy Bay was the 200-ton *Flying Foam* of Bridgewater, in January 1936. Built in St Malo in 1879, she was a pure sailing vessel, never having been fitted with auxiliary power. She anchored between Puffin Island and Penmaenmawr to repair a sail and was caught by a worsening westerly wind. She dragged her anchors and her master, Captain Jackson, sent up distress signals. The Beaumaris lifeboat was launched and took off the crew of seven, with the master, his wife and the ship's cat with her kittens. Local trawlermen later boarded the vessel while she was being driven ashore

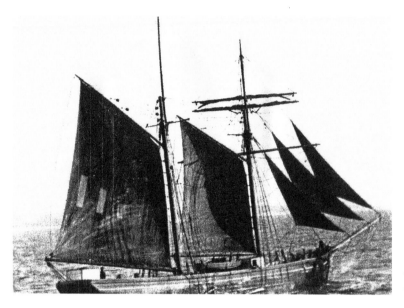

The *Flying Foam* under full sail.

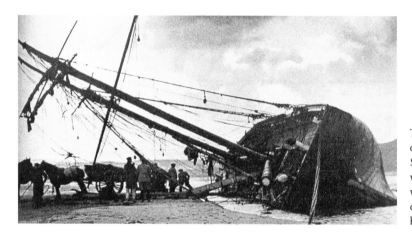

The *Flying Foam* on the West Shore beach, where she was wrecked. Her cargo of coal is being salvaged.

DID YOU KNOW?

There have been two lightning fatalities in Llandudno. In 1861 the barman of the Washington Hotel, on the Promenade at Craig-y-Don, looked out during a thunderstorm and saw lightning strike dead a local carriage driver, Thomas Jones. When the victim was examined in the hotel's stable the only mark on his body was a slight singeing of hair under one ear. The lightning had also damaged the carriage and injured the horse. There was one other lightning incident, in the same era, when Mr John Davies, a carriage proprietor, while taking a group of visitors on the Marine Drive, was struck and killed. Maybe their horsewhips acted as conductors for the lightning?

and tried to pump her out, but she was grounded and began to break up. The wreck was sold to a local coal merchant, Owen Thomas, who removed her cargo with his horse and cart. The remains can still be seen several hundred yards out from the Dale Road car park at West Shore.

Llandudno Coastguards

The origins of the Coastguard Rescue Service go back to the early nineteenth century when a Captain George Mumby invented a line-throwing apparatus. There had been many shipwrecks around the coast of Britain in which boats were close inshore but cut off by raging seas, much to the frustration of rescuers. Some method of firing a line across a chasm was needed and Captain Mumby's device did just that. It was a mortar which fired a special cannonball with a short chain attachment and a coil of thin rope. Once fired, the rope would be grasped by the shipwrecked sailors so they could then haul a much thicker rope across from the rescuers. A breeches buoy, a sort of cradle, would then be hauled across and the sailors could be winched ashore.

There had been much concern in Parliament about the appalling loss of life at sea at that time of sailing ships. In 1815, duly impressed by the device, the House of Commons ordered that this equipment should be placed at forty-five sites with bad wreck records. The Great Orme, Llandudno, was one of these. Gradually, a more efficient rocket system was introduced and by 1881 there were 195 Life Saving Apparatus Teams in place along

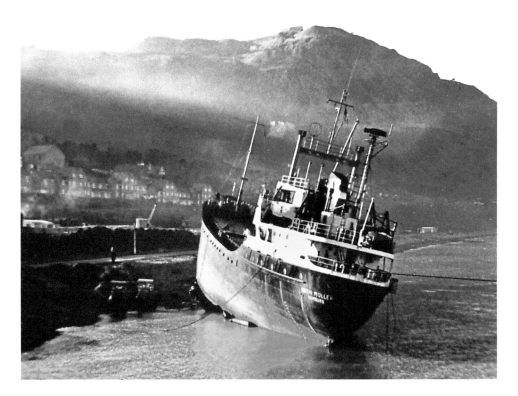

The German coaster *Rethi Muller* stranded on the beach at Penmaenmawr.

the coasts of England and Wales. Up until the Second World War the mode of transport to carry the equipment was a wagon drawn by two horses.

On 5 November 1967 the Llandudno team of coastguards made their first and only rescue by breeches buoy in the 152 years since it had been introduced. The 1,000 ton German ship *Rethi Muller*, while waiting to load stone at the 614-ft-long quarry jetty at Penmaenmawr, was hit by 50 mph winds. At 10 a.m. the captain, Franz Hintz, reported that despite extra mooring ropes the pier would not hold the ship and shortly afterwards it broke free and sprung broadside to the sea. The snapping of the last of the lines caused the bo'sun to suffer a broken leg. The ship dragged her anchor towards the lee shore. An RAF rescue helicopter took the injured seaman off at the height of the storm. The Llandudno Lifesaving Apparatus was called and, led by Mr Eric Williams, a rocket line was put aboard the ship. A woman was brought ashore on the breeches buoy and who was apparently the captain's wife. The German crew decided to stay with their ship, which was by now aground on the beach. Much later, in transpired that the lady concerned was from Llandudno and had been 'entertaining' the crew!

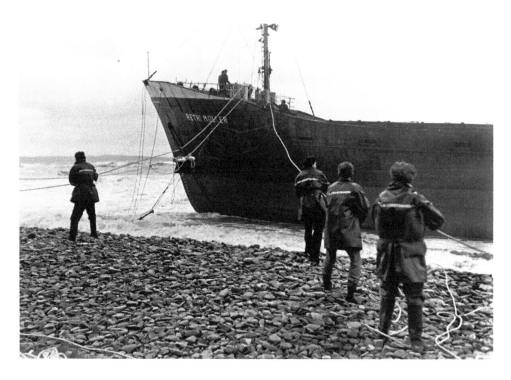

The Llandudno Coastguard Rescue Team at work to deploy the Breeches Buoy Rescue Apparatus and rescue a lady from the *Rethi Muller*.

2. Natural Phenomena

The Copper Mines

The earliest copper mines on the Great Orme date from about 1800 BC and are believed to be the oldest known in Europe. They are of major international importance to students of the Bronze Age. It is likely that the ore was sent to Cornwall to be smelted with tin to make bronze. With the advent of the Iron Age the mines were abandoned, and they remained untouched until the eighteenth century when, with the advent of new mining technologies such as explosives, new mines were sunk and extensively worked until about 1848. The copper produced was of very high quality and much in demand for cladding the bottoms of the nation's fleet of wooden battleships. By the middle of the nineteenth century, ships were being made of iron so the demand for copper diminished and in addition there was competition from cheaper, foreign copper ores. About 5 miles of tunnels, galleries and shafts were left by the miners. Some of the more spectacular of these have been opened to the public to marvel at – the Great Orme copper mines are well worth a visit.

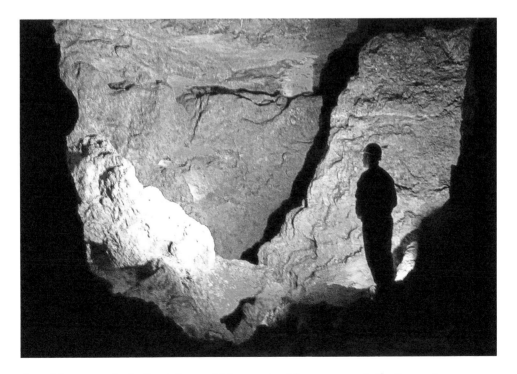

One of the caverns in the Great Orme, which was mined for copper ore in the Bronze Age.

Kendrick's Cave

Thomas Kendrick was a lapidary (stone polisher). He made jewellery from pebbles he collected off the beach in one cave (which is still visible from Upper Mostyn Street), while using another cave lower down as his showroom. These caves are in the private grounds of Ardwy Orme, just behind and above the Empire Hotel. In 1879 he decided to enlarge his show cave and during the excavations discovered a hoard of bones and artefacts. These seemed to indicate human occupation, possibly from the Stone Age. The most significant find was a horse's cheekbone carved with chevrons. This is now in the British Museum as the only artefact of its kind found in Britain (yet commonly found in caves in the Pyrenees) – in other words of national importance.

Radiocarbon dating, which had previously dated the bones to 12,000 years old, has been repeated and revealed that they are in fact about 16,000 years old. You might ask at this point 'so what?' Well, analysis reveals that the diet of humans alive at this time was mostly marine and in particular seal. Ice sheets still extended over a large part of Britain and the Continent, so that sea levels were substantially lower than they are today. It is hard to put a figure on it, but the shoreline could have been up to 10 miles from the Great Orme. Would the early natives have trekked all that way through a forest to make their home here? Even as recently as 6,000 years ago there were forests right up to what is now our low water mark in the bay and you can actually still see the stumps and roots of these trees near the Little Orme.

Excavation of Kendrick's cave found no evidence of actual occupation, so what can be the explanation? It seems most likely that the cave was only used for burial purposes.

The Hiding Cave

Below the lighthouse, a few hundred yards to the west at about 30 ft (9 m) above sea level, is a well-appointed grotto shown on the maps as Y Llech or the Hiding Cave, but

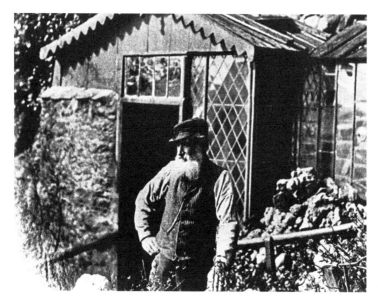

Thomas Kendrick.

also known popularly as Smuggler's Cave. It is hexagonal, about 7 ft (2 m) in diameter and about 8 ft (2.4 m) high. There is a continuous stone bench around the interior. In the middle is a plinth which once supported a circular table, now long gone. There is also a stone basin fed by spring water. The story goes that monks from Gogarth Abbey would come here for a retreat or to hide from the anti-Catholic authorities. But this does not ring true because what was known locally as Gogarth Abbey was in fact a palace belonging to the Anglican Bishops of Bangor. The cave's real purpose was revealed quite recently in a BBC TV programme – it had been excavated and equipped in the sixteenth century as a summerhouse for the Mostyn family, who lived at nearby Gloddaeth Hall.

Around 1824 a youthful Charles Darwin visited the Great Orme at the invitation of a local character known as Old Price. They went hunting for the Samphire (Crithmum maritimum), a sort of sea cabbage and rare epicurian delicacy, which grew on the cliffs below the lighthouse. As it grew high on the cliff, the method for harvesting it was to shoot it down with a shotgun, then collect it where it had fallen. Darwin must have seen the cave, because the path down the cliff passed beside the entrance.

Hornby Cave

Just a quarter of a mile to the west of the Great Orme lighthouse is the Hornby Cave. It was named after the 280-ton Liverpool brig *Hornby* which, with a crew of thirteen, two passengers and a general cargo valued at £60,000, was wrecked on the rocks of the Great Orme during a storm on New Year's Day night in 1824.

It was on route from Liverpool to Rio de Janeiro. There was no lighthouse on the Great Orme then and faced with strong northwest winds the vessel was making no progress. During the second night the mate suggested to his commander that they should try to go into the port at Beaumaris, in the Menai Strait. Apparently the master said, 'I had rather be at sea for ever than go there'! Thinking that it was time to go about, he sent a man to loosen the jib. The man, John Williams, had no sooner got on the jib-boom when he saw a rock

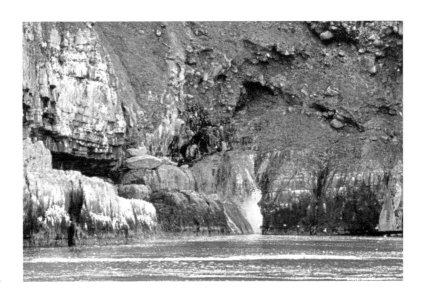

Hornby Cave, Great Orme, scene of the wreck of the Liverpool brig *Hornby* in 1824.

below him and jumped onto it. Subsequently, he could see no sign of the ship and the next morning clambered up the steep cliff and made his way over the Great Orme to the copper mines, where he told his story to miners gathered around the Llandudno smithy. At first they did not believe him but were later convinced by the sight of the wrecked vessel.

At Caernarfon Assizes, ten people were later convicted and three acquitted of plundering the wreck. Williams spent the rest of his working life as a copper miner in Llandudno.

Pigeon's Cave

Below the first promontory on the Marine Drive lies Pigeon's Cave. It is above a bay with a sandy beach named Porth yr Helyg (harbour of the willow trees). The cave itself shows signs that it was partly excavated, probably with the prospect of copper mining.

There was great excitement in 1898 when brothers Lewis and Arthur Ridell found, while exploring, two Celtic-type gold earrings, a bronze palstrave (an axe head designed to be fitted in a socketed handle) and a socketed bronze point weighing 10z, which may have been used as an awl for leather work. So valuable were these objects that they are now housed in the National Museum of Wales, Cardiff.

A tale was popular at the time relating to part of the cave which is a narrow ledge of rock at sea level, named Mainc-y-stiwardiaid (Bench of the Stewards). The story went that any Mostyn estate agent who offended a tenant would be sentenced to spend one or more tides, naked, on the ledge (there is no record of an agent ever having suffered such an indignity!).

There is evidence, however, of nearby of quarrying – the stone was destined for the new Telford Suspension Bridge, Conwy, which was completed in 1826. The large dressed stones would have been slid down man-made chutes into cargo vessels for shipment round the Great Orme. These chutes can still be seen, as can some of the stones which never made it into the vessels.

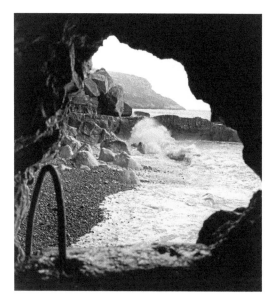

Pigeon's Cave, Great Orme.

3. Historic Visitors and Memorials

Barbary Pirates

The tower on Bryniau Hill overlooking Llandudno's Maesdu Golf Course is a remnant of a serious threat to North Wales in the seventeenth century – in this case Barbary pirates, sometimes known as privateers or corsairs, from the Barbary Coast in North Africa. For centuries these pirates had been the scourge of merchant ships and ports in the Mediterranean. They would take the cargoes and Christian sailors into slavery or for ransom. The threat came nearer to home when, in 1631, the harbour village of Baltimore in County Cork was sacked by the pirates, who took about 100 young men and women in good physical condition. The men would become galley slaves or be sold in slave auctions, and the women used as concubines in harems or within the walls of the Sultan's Palace. Attractive women and boys would be sold off as sex slaves. The well-off could be ransomed. Only two people ever returned to Baltimore, which lay abandoned until about 1800.

Sir Thomas Mostyn, who was the largest landowner in North Wales, had many official titles including the High Sheriff of Flintshire, Caernarfonshire and Anglesey. He was Muster-Master and Custodian of Crown Arms and Armour. He had to take action faced with this threat not just to shipping but to the population at large. He built an early warning system – a chain of four lookout towers – on Bryniau Hill, at Llandrillo yn Rhos, Abergele and Whitford, Flintshire. They were all stone towers except at Llandrillo, where a lookout was added to the existing church tower – you can still see it today. All the towers were on elevated land and within sight of each other so they could signal each other by means of lighted beacons. Should a privateer be sighted – their sails being very distinctive – the watchmen would raise the alarm with residents living in the area, so they could retreat inland to hide.

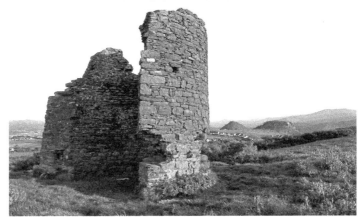

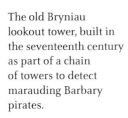

The old Bryniau lookout tower, built in the seventeenth century as part of a chain of towers to detect marauding Barbary pirates.

There is actually no evidence that the pirates came to North Wales, but it has been estimated that over a million Europeans were taken during a period of 250 years.

Printing Cave

Above the cliffs of the Little Orme there is a cave where the first book in Welsh was printed during the reign of Queen Elizabeth I. This was a difficult time for Catholics because Britain was then a largely Protestant nation, but the Queen was tolerant and allowed Catholics to continue to worship quietly, so long as they were not seen as a threat to the monarchy. However, magistrates were ordered to condemn any unlawful assembly of Catholics.

Many devout Catholics found sanctuary on the Continent but were determined to continue the struggle to restore Britain to the Catholic faith. As part of their plan, they produced 'Y Drych Cristannnogawl' (The Christian Mirror) for distribution in Wales, but production problems arose because their compositors had difficulty with the Welsh language.

In 1586 they contacted Robert Pugh, an ardent Catholic of Penrhyn Old Hall, and he took the authors of the book to the cave on the Little Orme where they were able to set up their printing press. The cave had a well-concealed entrance passage about 2 ft high and 7 ft long, and only visible from the sea. This led to the main cave, 10 ft by 12 ft and 15 ft high. From it a 15-ft-tall shaft served as a chimney.

The author examines the low entrance to the Printing Cave.

A typical scene in a printing workshop in the sixteenth century.

They had been working on the book for nine months and had only partly completed it when a local man in boat spotted smoke coming from the chimney. He reported it to Sir Thomas Mostyn, local Justice of the Peace and staunch Protestant, of nearby Gloddaeth, who ordered a force of forty men to march to the cave. By now it was dark and with the entrance so restricted it was decided that it was unsafe to go in. They camped nearby until dawn broke, and when they entered the cave they found that the occupants had escaped through the chimney – leaving the printing equipment but taking the copies of the book with them. Lord Mostyn's cohort threw the printing press and other equipment over the cliff.

The cave was excavated in 1961 and although no remains of lead type was found, there were imprints of joists on the ground, suggesting a wooden floor and that a structure the size of a printing press had been used there. It is possible that the printers had taken the type with them. Three copies of the book still exist.

Lewis Carroll and Alice Liddell

'Curiouser and curiouser!' cried Alice – a statement resonant in Llandudno today: Did Lewis Carroll really visit Llandudno and was he so inspired by certain features that he incorporated them in his famous *Alice* stories?

In 1933 the great and good in Llandudno had the famous White Rabbit statue erected on the West Shore. The accompanying plaque claims that Lewis Carroll was inspired to write *Alice in Wonderland* after rambling with Alice Liddell on this very same shore. This claim has always been refuted by academics and others; however, things are not always what they seem, as Alice would agree!

It was on a rowing trip on the Thames at Oxford in July 1862 that the Revd Charles Lutwidge Dodgson (Lewis Carroll) told the story of *Alice's Adventure Underground* to Alice Liddell and her two sisters.

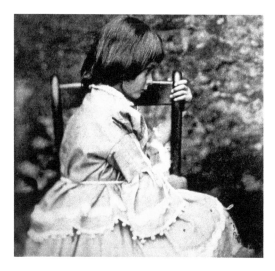

Photographic portrait of Alice Liddell, taken by Lewis Carroll.

Alice was so entranced by the story that she pleaded with him to write it down. He did so and in 1863 presented her with a manuscript of the story, accompanied with his own illustrations. It was in fact only a short story, with features such as the tea party and many famous characters missing; it wasn't until 1864 that he completed and published the *Alice in Wonderland* story we now know today.

There appear to be some Llandudno influences which inspired the story. In 1861 the Liddell family stayed at St Tudno's Villa, North Parade – we know this from the census. Just 60 odd yards from the villa was the entrance to the disused tunnel of the Ty Gwyn Copper Mine, which by then had become a tourist attraction. I doubt if the Liddell girls could have resisted the opportunity to be led, along with other visitors, by an ex-foreman of the mine on an underground adventure to explore the tunnel, chambers and artefacts left by the Victorian miners. Lewis Carroll was then a regular visitor to the Christchurch Deanery (the Liddell's home), where Alice must have told him, with great excitement, of her adventure underground.

The derelict mine pumping engine of the Victorian Ty Gwyn Copper Mine.

In fact the manuscript describes Alice seeing the White Rabbit and following him into his burrow, only to find herself in a tunnel. Ty Gwyn translates as 'White House' – it surely follows that this could have been the White Rabbit's home. The original entrance has been lost, but the tunnel is still accessible via a manhole and has been extensively explored and mapped by the Great Orme Exploration Society, who found, in the tunnel, footprints in the clay of both adults and children.

In his book *Did Lewis Carroll Come to Llandudno?* Dr Mike Senior makes a substantial case, based on evidence not previously considered, that Carroll did in fact come to

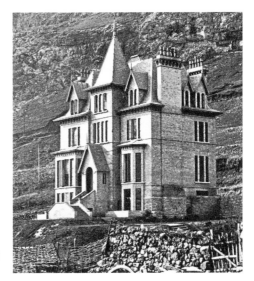

Right: Penmorfa on West Shore, the holiday home of the Liddell family.

Below: In 1863 Lewis Carroll posed with the four Liddell girls and their governess at Penmorfa.

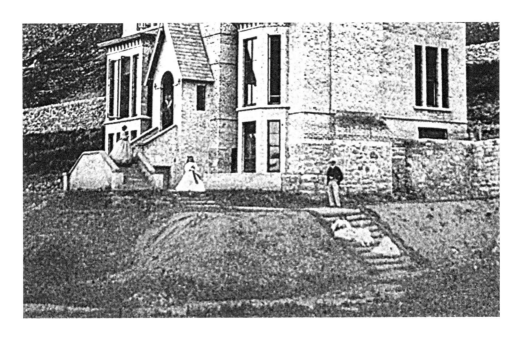

Llandudno, most likely in January or February of 1863. The clincher is the photograph of Penmorfa, the Liddell's holiday home, included in Dr Senior's book. It shows a man in light trousers clearly not a workman, more a man about town. There are four girls in the picture. On the steps below the man is 8-year-old Edith Liddell with her 3-year-old sister Rhoda (though she is just a blur because she was not able to keep still for the exposure, which might have taken more than a minute and a half). To the left of the man is 11-year-old Alice – she appears to be stepping down towards him. Note the party dress and the sash, not usual outdoor attire. Above her, apparently ascending the steps, is 14-year-old Lorina, and in the doorway is Miss Prickett, the governess. This is a very well arranged grouping, typical of Carroll's work as a prolific and renowned amateur photographer. I have no doubt that the man is Carroll. The person who uncapped the lens for the exposure, I would guess, was the girls' 16-year-old brother Harry.

There is no doubt about the provenance of the photograph. It is one of two – the other showing the rear of Penmorfa from the zigzag path up the Orme, which were presented to Alice by Lewis Carroll, mounted in an album, early in 1863.

The evidence critics use to refute this is that there is no reference to a visit to Llandudno in Carroll's diaries. These are not in fact diaries but journals. Sometimes there are a lot of entries – at other times many days pass with no account of his movements. Then there are the missing glass negatives. Apparently, Carroll numbered his photographs as he took them. There is an estimate that he took 2,641 photographs in his twenty-four-year-long career. It seems that he took a month in 1875, working ten hours a day, to go through his collection, numbering, cataloguing and erasing those that did not meet his self-imposed high standards. Many of his best negatives had been damaged by damp, in storage. The evidence points to him having rejected about 500 and then catalogued the rest. Sadly, all his negatives were sold at auction after his death and no trace of them has ever been found, which might suggest that they were bought to glaze a glasshouse. Fortunately, many prints and albums have survived.

Prince Leopold

This is a fascinating story discovered by Ivor Wynne Jones, author of *Queen of Welsh Resorts*. In September 1873, while strolling on the Little Orme, a Mr Lewis Davies of Ty Ucha Farm found a tin box with a note inside, which read as follows:

Prince Leopold, son of Queen Victoria, was on this spot August 23rd 73, on a visit to Llandudno, staying incognito at the Imperial Hotel; was attended by Major-General Patten on this rough ramble hither. His Royal Highness came by sea from Cowes, Isle-of -Wight; but resolved not to do so again, having suffered severely from sea sickness. His Royal Highness humorously wishes me to add that he would have much liked a tree to be planted on this rock in commemoration of his visit, but was restrained from following the example of Her Majesty, his mother, first because it would be very difficult to get a tree up here; secondly if a tree were got up, it would be equally difficult to make it grow; and third and last, such a proceeding if carried out, would be likely to cause a sensation leading, perhaps, to his identification, of which His Highness commanded me to write the above, because knowing the loyalty of the people he (Prince Leopold) thought it would occasion pleasure to some to know that a son of Victoria stood on this spot.

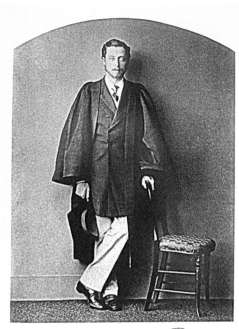

Photographic portrait of Prince Leopold,
taken by Lewis Carroll.

It was signed 'Aide-de-Camp Patten'.

Why did Leopold make this incognito, tortuous journey to Llandudno? One can only speculate, but there is circumstantial evidence which might explain it. The connection is with Alice Liddell (of *Alice in Wonderland* fame). Prince Leopold was a student of Lewis Carroll at Christchurch, Oxford in 1872 and was often entertained by the Liddells at the Deanery. While he was a year younger than Alice (she was twenty-one), there was an obvious affection between them and it might have been an ambitious desire of Mrs Liddell to marry one of her daughters into the Royal Family. A romance between them may have flowered in 1873 but because of class views of the time it was never going to lead to marriage. Royals in those days were expected to marry royals. Penmorfa, the Liddell's family home in Llandudno, on the West Shore, had not been visited by the family for several years and was being sold. The question is, could Alice have visited Penmorfa for the last time in August 1873 for a secret tryst with Leopold?

When Alice was married in 1880 she received a letter from the Prince sending his 'warmest and most heart-felt wishes for your future happiness,' adding, 'I shall think much of you and your family tomorrow; for you know how I have felt and sympathised with you and yours, in your joys and your sorrows.'

Two years later Leopold married Princess Helene of Waldeck. When Alice's second son was born in January 1883 she named him Leopold and when Prince Leopold's daughter was born a few weeks later she was named Alice (she was to become the future Countess of Athlone).

Leonard Bright

John Bright was elected MP for Durham in 1843 and sat in the House of Commons between 1843 and 1889, supporting universal suffrage and the secret ballot. He opposed the Crimean War and was accused of treason by fellow MPs. He was of the opinion that the Indian Mutiny was a result of British misrule. He lost his seat, but in an 1857 by-election he was returned as the member for Birmingham. He supported Abraham Lincoln's opposition to slavery and was shocked by the outbreak of the American Civil War. In 1868, Gladstone promoted Bright to President of the Board of Trade.

The Bright family loved Llandudno and spent many happy holidays here. One afternoon in 1864 they were walking through St Tudno's churchyard on the Great Orme when their 5-year-old son Leonard exclaimed, 'Oh Mamma, when I am dead I want to be buried here.' John Bright and his wife laughed at the child's innocent remark and returned to the St George's Hotel for tea. That night Leonard became ill and within a week he had died of scarlet fever. Heartbroken, John Bright walked to the rectory in Church Walks to see the Revd John Morgan and ask that his son's last wish be granted. A place was found near the church door. John Bright visited the grave every year until he died in 1889, becoming a familiar figure in Llandudno. He regularly read *The Times* at the original library and kept a

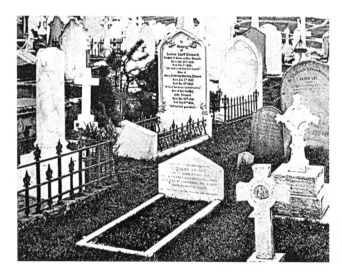

The grave of Leonard Bright in St Tudno's graveyard on the Great Orme.

horse in what became known as 'John Bright's Paddock' at the junction of Church Walks and Abbey Road. He even provided pensions out of his own income for some of the aged poor in the town. But his most permanent memorial is John Bright's School on Maesdu Road.

The Hidden Memorial

At the foot of the Rhiwledyn Cliffs on the Little Orme, beyond the eastern end of Llandudno Bay, is a stone memorial commemorating a fatal accident. On Monday, 30 August 1897 Frederick Stone, a Derby solicitor, his wife and their son Hubert returned to the Mostyn Crescent Hotel having spent the day visiting the Menai Strait. They had tea and 14-year-old Hubert went out without informing his parents. His father assumed he had gone to the beach or onto the Great Orme. When he failed to return by ten o'clock his father went in search of him. He found no trace and the following morning reported the fact at Llandudno police station.

On the Thursday two local men took a boat and rowed around the base of the Little Orme. At the foot of a steep cliff just above the high water mark they discovered Hubert's body.

The following day an inquest was convened by the Caernarfonshire Coroner. Hubert's father gave evidence of identification and said that his son had gone to the spot to read a book. Having been cut off by the tide, Hubert had attempted to climb to safety, but fell onto the beach and was knocked unconscious. Dr Nicol gave evidence of examining the body and finding injuries to the legs, chest and chin – none of them serious enough to have caused death. In his estimation the boy had been dead for two days when discovered. In reply to the Coroner, he stated that there were no injuries to the head and that in his opinion shock and cold were the causes of death. The jury returned a verdict of 'Accidental Death', and expressed their sympathy with the parents.

In memory of his son and as a warning to others, Frederick Stone arranged to have a memorial to his son constructed at the foot of the cliffs, where the boy fell. On the memorial is the inscription: 'Sacred to the memory of Hubert Stone of Derby, who fell and died here on or about August 30, 1897, aged 14. God grant that we meet again in a Happier Valley.' Sadly, it did not deter others, as many other young men and boys have lost their lives on these cliffs since.

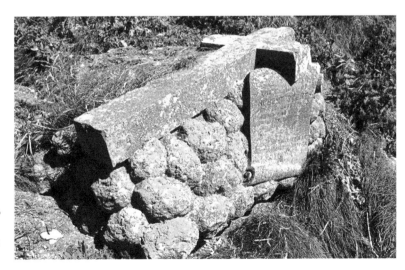

The memorial to Herbert Stone at the foot of the Little Orme.

Carmen Sylva

In 1890 Queen Elizabeth of Romania spent five weeks at the Adelphi Hotel (now the Marine). She was the daughter of European royalty and had married King Carol of Romania. In 1869 she wrote a novel about Wales and decided to visit the Principality of her dreams. She asked Prince Ghyka, the Romanian Minister in London, to find a remote spot for convalescence and contemplation for her. Prince Ghyka consulted the Prince of Wales who had visited the town in 1867 and 1880, and he provided Queen Elizabeth with his own personal railway saloon, upholstered in silk, to bring her to Llandudno.

Her first reaction at finding herself at a busy holiday resort was one of annoyance, but the following morning Lord and Lady Mostyn visited her at the hotel. In the afternoon, she was driven to Gloddaeth Hall for tea, the first of several visits. Within a few days she had visited the National Eisteddfod at Bangor and was admitted to the Gorsedd of Bards under her pen name of Carmen Sylva. She attended several concerts in the Pier Pavilion and went to such events as children's parties. She worshipped at Llanrhos Church. Her tours took her all over North Wales and she was entertained by the nobility at Penrhyn Castle, Baron Hill at Beaumaris and Mostyn Hall. She took frequent boat trips in the bay and as there was no jetty near the hotel a boatman, William Lloyd Jones, would carry her over the shingle. With royal consent he changed the name of his boat to *Carmen Sylva* and for the rest of his life he was known as the Royal Boatman!

Richard Codman gave a Royal Command Performance when he was instructed to move his booth up the Promenade and give a Punch and Judy Show opposite her hotel window.

Her patronage of traders in the town was still recorded more that seventy-five years later in the form of Royal Crests. Roads were also named after her: Carmen Sylva Road and Roumania Crescent and Drive.

When her stay was coming to an end, the town's children paraded past her hotel, where she waved from a window. At night there was a farewell concert in the Pier Pavilion and the next day she was given an official send-off by the Town Commissioners. Twenty-one lifeboat maroons were fired off the Great Orme as she set off at 8 p.m. to join the night train to London – never to return. In her last words to the Commissioners, she described Wales as 'a beautiful haven of peace'. This was later translated into Welsh as 'Hardd, Hafan, Hedd', which became the official motto of Llandudno.

Carmen Sylva died in 1916.

Queen Elizabeth Commemorative Medal.

4. Notable Local Residents

The Mostyn Family

The Mostyn family from Mostyn Hall, Deeside, also owned Gloddaeth Hall and Bodysgallen Hall in Llandudno. They were big landowners – much of which had been acquired through marriage. In 1796 they owned 750 acres of the 900 acres in the Llandudno parish. This represented just 1.5 per cent of their total land holdings of thirty or so estates, which stretched across North Wales and beyond.

Sir Thomas Mostyn (1796–1831) inherited the estate on the death of his father. It was a massive portfolio which included the land and commercial interests in the mining of coal, copper and lead, as well as agriculture, forestry and shipping. He became MP for the County of Flint and High Sheriff of Caernarfonshire. Leaving an agent to manage his Llandudno affairs, he divided most of his time between his three residences, Mostyn Hall, Swift's House near Bicester and Park Place, St James' London. The estate yielded an annual income of around £10,000 – hardly enough for his lifestyle, which involved hunting, horse-racing and gambling. Sir Thomas died in 1831, leaving the estate seriously in debt to the tune £120,000 (£9 million today). He was unmarried and without a legitimate heir.

He had made provision in his will for a life interest in the estate to pass to his third sister, Elizabeth Mostyn, wife of his hunting companion Sir Edward Pryce Lloyd, who was already aged 63. His older son, Edward, was also a hunting companion of Mostyn and as the heir apparent he began to operate as the power behind the throne.

Sir Thomas made a provision in his will that any inheritor must take the name of Mostyn or the estate would be forfeited. Sir Edward Pryce Lloyd was therefore formally

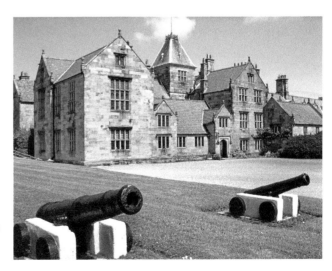

Mostyn Hall, seat of the Mostyn family, overlooking the Dee Estuary in Flintshire.

declared the first Baron Mostyn and his son would become the Honourable Edward Mostyn Lloyd Mostyn.

He took up where his uncle had left off, spending large sums on rebuilding Mostyn Hall. He too was into hunting and bought a stable of thoroughbreds, which proved to be highly successful. He also enjoyed the card tables.

This was at the start of the mania for taking the waters for medicinal purposes – triggered by the publication in 1702 of a book entitled *The History of Cold Bathing* by Sir John Floyer. He advocated sea bathing as a cure for practically every ailment known to mankind and also recommended drinking seawater. This was the start of the rush to the sea on which Llandudno was later founded.

In the early 1800s the ownership and control of Llandudno looked uncertain as the Mostyns were being sued by group of unpaid creditors: mortgages and the sale of land ensued.

Owen Williams, a 29-year-old surveyor, came to Llandudno from Liverpool in 1846 with his friend who had business at the Ty Gwyn Copper Mine. He claimed, some forty years later in a letter to a newspaper, that he saw then the potential for a fashionable 'Watering Place'. He wrote to Lord Mostyn expressing his views, and the two men met. However, it was hardly a novelty to the Mostyns as they had already developed a resort at Parkgate on the Wirral in 1797 and Rhyl in the 1820s. In fact, a newspaper article in the *Liverpool Mercury* in 1813 was a promotion for Llandudno as an ideal setting for a resort.

Realising that Parkgate did not have a future because of the silting up of the Dee Estuary and also the coming of the Chester to Holyhead Railway, the Mostyns turned their attention to Llandudno.

In 1836 a company of independent entrepreneurs put The St George's Harbour Bill before Parliament in a bid to turn Llandudno Bay into a port, by means of installing breakwaters across the bay. It was suggested that it could be used for packet boats crossing to Ireland. The Bill failed on the grounds that there was an insufficient depth of water in the bay for operation at all states of the tide.

Ireland had joined with Britain to become part of the United Kingdom in 1801. Thomas Telford had created the A5 Holyhead Road to carry the mail and politicians over to Kingstown, now known as Dun Laoghaire. Stagecoaches travelled from London to Holyhead, where packet boats took passengers on to Ireland.

By this time the railways were making great progress and in 1838 George Stephenson was commissioned to survey for a line from Chester to Holyhead.

By Act of Parliament the Chester & Holyhead Railway Company was given the go ahead. They appointed Robert Stephenson (George's son) as engineer for the project. The first section – to Bangor – was opened in May 1848 and a line from LlanfairPG to Holyhead opened in August. To start with, passengers were shuttled by stagecoaches over Telford's suspension bridge across the Menai Strait, until the famous Britannia Bridge was opened in March 1850.

So it seemed that the possibility of Llandudno becoming an important sea port was at an end. But no – in 1853 the St George's Harbour and Railway Company re-emerged with a new Act of Parliament giving them the go ahead to build a railway branch line from a new Llandudno Junction station to Llandudno. They also proposed to build a major sea

port with breakwaters, lighthouses, piers, docks, locks and quays. In the event, all they actually achieved was the building of the branch line, and to protect their Parliamentary rights they constructed a makeshift wooden pier. It was just 242 ft long and could be used by steamers only at high water. A year after it was built, a massive storm seriously damaged a section of it. Once repaired it continued to be used for another seventeen years until Llandudno's new pier was built. The company was unable to raise the finance for their scheme and so it was that Llandudno escaped being named St George's Harbour.

Meanwhile, the Mostyns had been working on the plans for the development of a stylish, high-class watering place at Llandudno. Their experience at Rhyl put them in good stead but there was one fatal flaw: a large area – from the beach in Llandudno Bay to a couple of hundred yards inland – was common land, largely sand dunes, but there were about thirty dwellings, or hovels as they were known then, made largely of turf (Ty Unnos houses). In ancient Welsh law, if a house was built overnight the builder could claim squatter's rights on the plot, with a small area around for growing crops. There were also two inns. In those days the answer was simple – in 1843 the Mostyns put forward an Enclosure Act to Parliament. This allowed landowners adjacent to the common land to take it over, in proportion to their existing holdings, thus dispossessing the commoners. The Act was passed and as the Mostyns owned most of the land adjoining the commons, they got the lion's share. However, there was no great hurry to evict the commoners – the plan was that if they were offered alternative housing at a modest rent, they could be encouraged to move. The Mostyns realised that a new resort would need a lot of workers to service it, so they planned to build a street of quite airy and spacious houses with indoor toilets, bathrooms, running hot water and small gardens in front for the dispossessed commoners. This was Madoc Street and by 1848 some twenty of the commoner families had moved there. Others made their own arrangements and many set up businesses – one hired out bathing machines and another carriages.

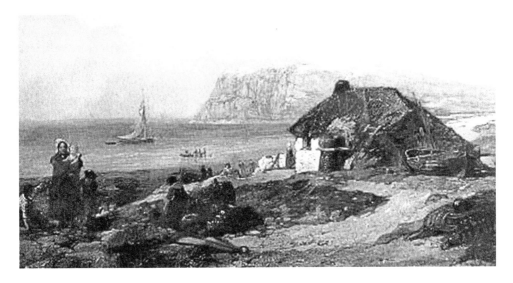

Ty Unnos hovel on Llandudno common land.

Both innkeepers were able to move their businesses into the new town. Owen Williams was then called in to make a survey of the land. The Mostyns' plan was to sell off seventy-five- or ninety-nine-year renewable leases on the plots. However, when they held an auction there were few buyers. Later, once building got underway, more leases were taken up. The biggest bonus for Llandudno was that the Mostyns ensured the leases required the buildings to comply with standards they laid down. These were devised by Owen Williams and included the width of the streets, the height of the buildings in relation to the streets, the size of the windows and the height of the ceilings, especially in the basements. Leaseholders also had to regularly maintain the buildings and these covenants still apply today. In effect, the Mostyns were the first to impose town planning. These leases were, some years later, extended by Act of Parliament to 2,000 years in the case of the seventy-five-year leases while the ninety-nine-year ones were extended to 999 years. The architects and surveyor, Messrs Wehnert and Ashdown of Charing Cross, London, were employed to draw up an overall plan of the town along with the architect and surveyor to the estate, George Felton.

While the buildings had to conform to a very general standard, they did not need to be identical. The result is the variety and wonderful sweep of the parades facing out to sea, which we still enjoy to this day.

Lady Augusta Mostyn

Lady Henrietta Augusta Nevill (1830–1912) was the second daughter of the 4th Earl of Abergavenny, who lived in Eridge Castle, near Maidstone in Kent. It seems that the Earl was delighted to be able to marry off his daughter to the Hon. Thomas Edward Mostyn, Lloyd Mostyn, who was heir to a massive portfolio of land. This included commercial interests in the mining of coal, copper and lead, as well as agriculture, forestry, shipping and some 50,000 acres in estates, stretching along the North Wales coast and into Deeside. In 1854 he came to Gloddaeth Hall with his wife – this was a crucial time as he was worried about the spendthrift behaviour of his father, Edward Mostyn, Lloyd Mostyn, the 2nd Baron (1795–1884), who had a predilection for gambling and fox hunting.

Thomas appointed an unofficial auditor to look at the estate's financial affairs. It was discovered that no accounts had been kept for some years and the estate was in debt to the tune of £720,000 (£31 million in today's money).

In 1861 Thomas died of tuberculosis aged just 31, so Lady Augusta found herself and her two young sons facing the loss of her home and future. She went to live at Birling Manor in Kent, where she took on the massive task of sorting things out. Financial matters had grown so severe that the whole of the estate – which was land rich but income poor – had to be put into the hands of an official receiver in 1863. To avert bankruptcy, some 7,500 acres of the various Mostyn estates in North Wales were sold, leaving reduced holdings at Mostyn and Gloddaeth.

Lady Augusta's father-in-law, Edward Mostyn, Lloyd Mostyn, now living in Mostyn Hall, advocated that Llandudno should be sold off so that they would not have to part with some shooting ground called Cwm, near Mostyn. Lady Augusta put her foot down, saying, 'we look upon Llandudno as the mainstay of the family'.

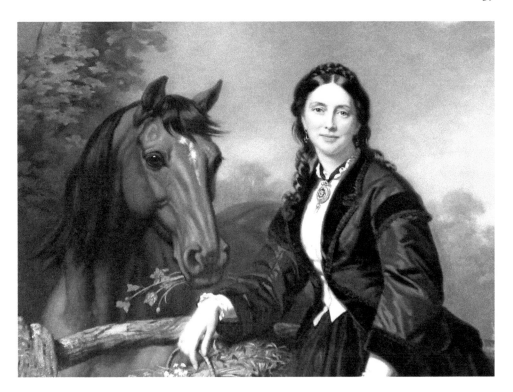

Lady Henrietta Augusta Mostyn.

The mid-1800s saw the rise of a new middle class in Britain, who were becoming increasingly wealthy as a result of the Industrial Revolution. Here was a way for the Mostyns to get out of debt. As early as 1794, the Mostyn family had bought the Rhuddlan Marshes and promoted a Bill in Parliament for enclosing, draining and developing them as a watering place, which is where Rhyl is today. A Baths House was erected in the 1820s, which was followed by the sale of plots of land for the building of terraces.

In 1848 the leases on the first plots of the proposed new resort of Llandudno were sold at Plas Mawr, Conwy. This was to be the turning point for the family's fortunes. This was most fortuitous as agriculture was in decline, so their commercial interests in Llandudno became the key to their future prosperity.

With things looking up financially, in 1876 Lady Augusta took the first steps to improve Gloddaeth Hall, with the building of a large West Wing, harmonious in style with the old building, two charming mock-Tudor lodges and a driveway to St Hilary's Church. In the lower part of Gloddaeth Park, she installed two lakes and had an ornamental bridge built.

In 1877 Lady Augusta's son, Llewelyn Nevill Vaughan Lloyd-Mostyn, reached his majority. There was a celebratory procession through Llandudno organised by a local committee, with sports and music from the Caernarfonshire Militia Band. The flag-bedecked steamer *Prince Arthur* fired a salute from the bay. Seven fat oxen and twenty-eight sheep were provided for a dinner that was given to a 150 of the 'Aged Poor'.

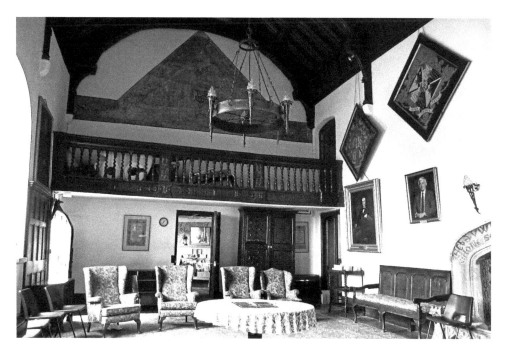

The Great Hall at Gloddaeth.

In 1879 Lady Augusta returned to Gloddaeth to take up residence and live in rather a grand manner. She had nineteen servants which included a butler, a valet, two footmen, two coachmen, two grooms, a plumber, a cook, two lady's maids, a nurse, three housemaids and three kitchen maids. To pay for this and other good works, in 1882 the estate sold off Bryn-y-Bia Farm and land for the building of the Craigside Hydro and an up-market housing development around Craigside – the first of these being Cloverly Lodge and Sunnyhill.

Lady Augusta started to take an active part in estate business and the social affairs of the town, being particularly interested in the buildings and architecture. She was also a talented artist and photographer. She became a major benefactor to Llandudno. She gave the land and paid for the construction of All Saints' Church, Deganwy, in memory of her parents. She paid for the chancel to complete St Paul's Church in Craig-y-Don and had a road constructed from Craig-y-Don, which we know today as Colwyn Road, to Siop-y-Roe at the top of Penrhyn Hill. Then she helped with the building of two schools and supported the building of Marine Drive around the Great Orme. In 1887 she gave a lease on the Happy Valley to the people of Llandudno as a permanent public park. This was followed in 1890 with the unveiling of an elegant drinking fountain to commemorate the Golden Jubilee of Queen Victoria, donated by Lady Augusta.

About this time she became aware that women artists in the area were bring denied membership of the Royal Cambrian Academy, Plas Mawr, Conwy and were confined to exhibiting in the Conwy Cockpit. She decided to strike back by having the Mostyn Gallery in Vaughan Street built just for them. It opened in 1901 but sadly, after just a few years, the ladies appeared to lose interest and drifted away.

In Llanrhos, just on the doorstep of Gloddaeth, on either side of Llanrhos Church, was a public house, The Mostyn Arms Hotel, with tea gardens and tennis courts and The Queens Head.

Lady Augusta decided that the estate workers were imbibing too much and it was affecting their productivity – so she devised a plan. In 1898 she did a deal with the owner of the Mostyn Arms, Sam Hughes, to give him a freehold plot of land a mile away, nearer the town, for him to build a new hotel. This was the Links Hotel which is still there today. The Queens Head, it seems, moved to Glanwydden village, about 2 miles away. To provide for her thirsty workers, Lady Augusta had the Llanrhos Temperance Hotel built just across the road from the church in 1908. It quickly became known as the Cocoa House.

On a more personal level, she visited a farm labourer, John Stevens, who had lived in the Bear's Cave, above the West Shore tollgate for fourteen years, and gave him an iron bedstead to make him more comfortable. She might have offered to find him another home, or maybe he was just happy there!

Lady Augusta's son, Llewellyn, inherited the title to the estate in 1884. He became Llewelyn Nevill Vaughan Lloyd-Mostyn, 3rd Baron. He moved to Mostyn Hall, where he lived the life of a rich Edwardian peer, with a country estate, a house in London and a steam yacht berthed at Mostyn Docks.

Lady Augusta remained at Gloddaeth until her death in 1912. She was the last Mostyn to live there. It became a girls' school in 1935 and St David's College in 1965, catering first for boys and today for both sexes.

DID YOU KNOW?

With the introduction of the first roll film box cameras for the general public, there grew a substantial need for laboratories to develop and print these films. A visitor could take his roll of film into a chemist's shop and just 24 hours later pick up a neat folder containing black and white holiday snaps with the negatives. Probably, the biggest laboratory in Llandudno was Brian Bell's establishment in the old stables in Primrose Passage, Craig-y-Don. Clearly, there were a lot of busy nightshifts for the technicians to meet the demand during the summer, but not much in the winter!

Henry Pochin

This is a fascinating Victorian story of upward mobility. Henry Pochin was born the son of a Leicestershire yeoman farmer in 1824. He went to Manchester and entered an apprenticeship as an industrial chemist. At the age of 21, he was taken into partnership and when his partner died he became the sole proprietor of the business. He met his wife, Agnes, and they were married in 1852.

Pochin's invention, which rocked the world, was white soap. Up to this time soap was a murky brown in colour. He also produced a chemical used in the production of paper for the printing industry.

He made a fortune and developed Haulfre between 1871 and 1876 as a private pleasure garden. It had an aviary, a greenhouse, summerhouses and walkways all with stunning views of Llandudno, its bays and Snowdonia. 'Haul' is Welsh for sun and 'Fre' for hill.

In 1875 Pochin bought Bodnant Hall in the Conwy Valley. He extensively altered the eighteenth-century hall there and designed the 80-acre Bodnant Gardens (now a National Trust attraction), creating the famed Laburnum Arch and planting the towering Redwood trees.

An early owner of the house at Haulfre was Thomas Lipton, famous for his Lipton's Tea, and another owner was John Walker, whose fortune came from Walker's Brewery.

In 1928 Llandudno Urban District Council bought the estate for £5,000 and the following year it was opened as a public park by former Prime Minister, David Lloyd George MP. Pochin's old villa served as tearooms. A popular feature was Invalid's Walk, a gentle path which runs along the hillside to West Shore and can still be used. Visitors can also climb a zigzag path up the Great Orme. The gardens are now managed by Conwy County Borough Council, which remodelled them in 2001 with support from the Heritage Lottery Fund.

Haulfre Gardens on the Great Orme, overlooking Llandudno Bay.

The Water Boys

A common sight in 1850s Llandudno was the water boys. These lads had a donkey with panniers carrying what appeared to be milk churns, yet in fact they carried water. Llandudno village was totally dependent upon wells and springs and these boys carried water and supplies to the lighthouse and remote houses on the Great Orme. The varied quality of the natural water was seen as a possible threat to the town's development as a health-giving resort, and something had to be done. In 1855 the Town Commissioners engaged John Hughes to pump water from Brooke's Well in Water Street, near the Royal Hotel. He manually pumped the water for three hours in the morning and three in the afternoon for a wage of 15s per week, with the help of an extra man on Saturdays at 2/6d.

It was soon realised that this would not be enough, as the building of the town had resulted in an increased demand, and a steam pumping engine was installed. In addition, the Commissioners drew up a plan to collect water from the Fynnon Gogarth Spring, which is located 420 ft above sea level overlooking Conwy Bay. Along with this supply they also had an underground service reservoir built 200 ft above sea level in the Happy Valley, under what is now the putting green. They also had a substantial reservoir built 250 ft above sea level to catch the water from St Tudno's spring, just below the church, which was piped to the Happy Valley reservoir. This gave a good head of water for the town. However, the water boys still supplied the houses on the Great Orme, which were too high for the water supply to reach.

But all these measure were not enough and in 1861, a dry year, water rationing had to be enforced by turning the supply on for just one period per day.

These problems continued off and on for many years until 1880, when water supplies were obtained from Lakes Dulyn and Melynllyn high up in the Snowdonia mountains above the Conwy Valley.

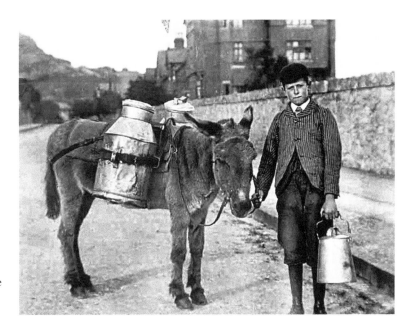

William Evans, one of the boys who transported water and groceries to customers on the Great Orme by donkey.

DID YOU KNOW?

In 1860 John Hughes established a fish and poultry business at 12 Mostyn Street, which was passed down through three generations, the last being Enoch Hughes. He created a novel business of supplying local live lobsters to the best Paris hotels. He kept them in tanks in the basement until an order came in, then he would pack them in wet sawdust to be transferred by road to Manchester, then by air to France. By 1967 he was supplying several hundred lobsters a day in the season, most of them from Cardigan Bay.

Punch and Judy

In 1831 Richard Codman was born into a family of Hungarian Romany origin, living at that time in Norwich. After leaving home aged 18, he became a travelling entertainer, playing a banjo and fiddle at fairs and for a time he took part in bare-knuckle fights.

In 1859 he married Charlotte Haskey of Birmingham and inherited a showman's horse-drawn caravan. The couple travelled around fairs until in 1860 they reached Llandudno, where their horse promptly died. Unable to afford to buy another one, Richard looked around for inspiration and employment. He found it in driftwood on the beach, from which he carved the Punch and Judy puppets (originally Punch and Joan), some of which are still in use.

Richard started performing on the Promenade but in 1864 was banned by the Town Commissioners as they did not like 'Punch and Judy, his dog and all the paraphernalia belonging thereto'. He had to move to a site in a cul-de-sac next to the Empire Hotel but he needed to get back onto the Promenade where the crowds were. He successfully appealed and there has been a Professor Codman on the Promenade at Llandudno ever since.

The Queen of Roumania, who in 1890 was staying in Llandudno, had heard of Richard Codman and sent instructions that he should move his booth up the Promenade so that it was opposite her hotel and perform a show which she would watch through her window! He also gave four Royal Command Performances to Queen Victoria and the Prince and Princess of Wales at Sandringham and Windsor.

Richard needed employment during the winters and started to spend them in Liverpool, performing in Lime Street (St George's Plateau). When Richard's eldest son, John, was 18 he took over at Liverpool permanently. During the winters Richard is known to have performed in Rhyl (Punchinello – as in the original Italian), Bournemouth, Hastings and York – where he performed for '1,000 waifs and strays' – which is commemorated by a plaque on the wall of York Museum. Richard also undertook two American tours. His four daughters all became actresses, Leonora being the most famous. John became involved in the early days of the film industry, touring music halls in Wales and Lancashire with his mobile cinema showing programmes of films that he had made. He also established some early fixed cinemas, though not in Llandudno.

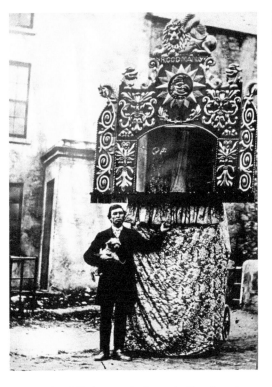

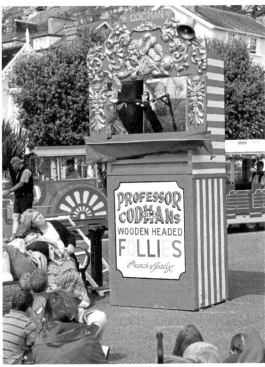

Richard Codman, who brought Punch and
Judy to Llandudno in 1864.

The Punch and Judy show today, still on
the Promenade.

In 1909 Richard died and his youngest son, Herbert, took over in Llandudno. During the
Second World War, Herbert visited Ireland and went off for a day's fishing, where he had
a remarkable conversation with the Captain of a German U-boat which had surfaced. He
wished to be remembered to 'a Herbert Codman' whom he had seen performing Punch
and Judy in Germany before the war! Herbert was also notable for having left the booth
during one of his Llandudno shows to swim out to rescue someone in trouble in the sea;
having completed the rescue he carried on with the show!

Herbert died in 1961, but the family still carry on the tradition in Llandudno.

Professor Beaumont

Born in Hammersmith, London in 1854, Walter Beaumont took up swimming at the age of
6 and by the age of 12 had already saved seven lives. He made rapid strides as an amateur
before launching as a professional. He held many world records for lifesaving, remaining
underwater, scientific and ornamental swimming, and being the fastest swimmer.

Between 1898 and 1911 he was the licensee of the Kings Head public house in Llandudno,
but he wasn't really a businessman and went bankrupt. As 'Professor' Beaumont, he used
to give spectacular high-diving demonstrations off Llandudno Pierhead and amazing
underwater displays in a glass-sided tank in the Pier Pavilion's Egyptian Hall. He held the
world record for staying underwater for 4 minutes and 35 seconds. He would drink a bottle of
milk, smoke a cigar and pick up forty-nine coins by mouth – retaining them all in his mouth

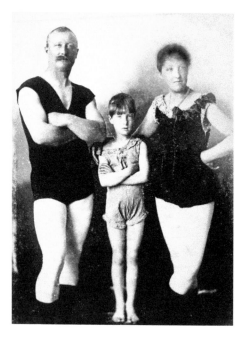

Professor Beaumont with his wife and daughter, who took part in his underwater act in the Egyptian Hall of the Pier Pavilion.

until resurfacing. His daughters, Alice and Lily, later joined him in the act. At dusk, Victorian divers were fond of performing the fire dive and it's possible that Professor Beaumont would have climbed into a sack which was then sprayed with flammable liquid and set alight before diving off the pier, getting free within seconds and surfacing unscathed!

When he was not giving displays he taught swimming, his pupils being mainly ladies and children. He was appointed 'rescuer of the beach' by the Town Commissioners and in 1903 at a dinner held in his honour they presented him with a gold watch and an illuminated scroll, recording that he had saved 113 people from drowning during his lifetime.

At the time of his death in 1924, Walter was living a relatively quiet life as the licensee of the Ferry Hotel at Tal-y-Cafn in the Conwy Valley. He owned a small pleasure craft, *The Merry Thought*, in which he took visitors for trips up the River Conwy. It is believed that the boat ran into difficulties and Walter – in ensuring that everyone safely returned to dry land – caught a chill which resulted in his death aged 69.

Stephen Dunphy

Around 1850 an Irish lady, Fanny Dunphy, came to Llandudno from Dundalk in County Louth with her son Stephen and started the family business – baking muffins in their home in Back Mostyn Street, now Somerset Street. Stephen succeeded his mother and in 1877 built a bakery and warehouse in Market Street. Fortuitously, the massive timbers needed for its construction became available from the demolition of Llandudno's first wooden pier, plus the masts and spars from the wreck of the Dutch Brigantine, *Catharina*, which had been carrying a cargo of salt from Runcorn to Riga and was wrecked on Llandudno beach.

Dunphy & Sons had several bakeries and high-class grocery shops licensed for the sale of wines and spirits in Llandudno and nearby towns, as well as a fleet of delivery vehicles.

Dunphy's shops are still remembered with affection for their colourful window displays, with jars and tins of every conceivable shape and size, polished mahogany counters, hams hanging overhead, men in aprons ready to cut whatever weight customers wanted on the slicing machines, and the rich aroma of coffee.

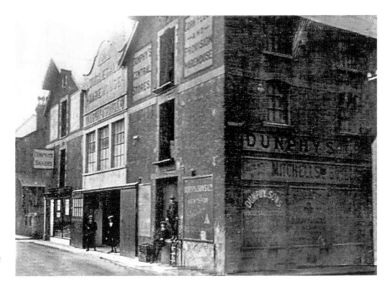

Dunphy's warehouse in Market Street.

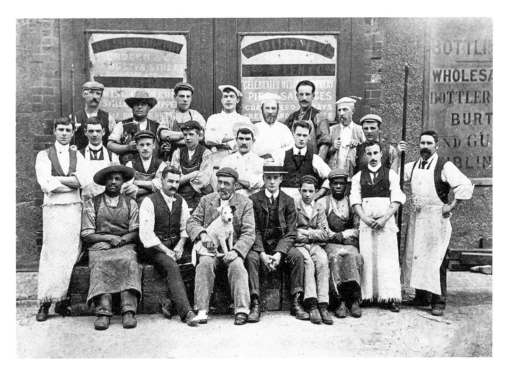

A group of Dunphy's workers. Seated in the centre, wearing a straw boater, is Stephen Dunphy, the boss.

Times changed, as did the grocery trade, and in 1972 Dunphy's closed. The warehouse was demolished in 1981 and the beams and spars were reused in the building of the Cottage Loaf public house and restaurant, which now stands on the site. The massive posts holding up the porch are a major feature in the bar.

DID YOU KNOW?

When Llandudno was being built in the 1850s, many of the buildings were erected during the winter so as to not disturb the visitors. During the summer the Welsh builders went, via Liverpool, to America where their skills were highly valued. Their influence on the east coast of America can still be seen in towns named Bala, Caernarvon, Swansea and Newport. There are no less than ten Cardiffs in the United States!

Billy Hughes

Bryn Rosa in Abbey Road was the boyhood home of William Morris Hughes, who was to become the Prime Minister of Australia. Born in 1862 in London to Welsh parents he was sent aged 4, after his mother died, to live with his aunt in Llandudno. He attended Dr George Robert's Grammar School in Cwlach Street and became a pupil teacher at St Stephen's School, Westminster. In 1884 he emigrated to Australia, where he became a trade union organiser and was elected to the New South Wales Parliament in 1894. The Australian Federation was formed in 1901 and he was chosen as Prime Minister in 1915. He came to Llandudno as part of David Lloyd George's War

Billy Hughes, Prime Minister of Australia, wearing his Australian Soldiers' slouch hat, given to him by veterans of Gallipoli.

Cabinet in 1916 and admitted that he had visited his old home and school. His last visit was in 1921, when he came to look again at Bryn Rosa but did not knock and ask to go in.

Billy Hughes was best known as 'The Little Digger' in Australia. He used to take the salute at the annual Gallipoli Veteran's Anzac Day Parade in Sydney, where he would wear the distinctive Australian soldier's slouch hat – given to him by the veterans. As he became older, a chair was provided for him by the Commonwealth Bank of Australia. After his death in 1952 the custom continued, the chair was brought out with his hat hanging over the back, adorned with a sprig of Rosemary – for remembrance. The custom continued until 1974 when the area was pedestrianised. His hat is still preserved in the bank's vaults and a plaque has been has been placed on the bank wall to commemorate the ceremony.

He was one of only two Welsh-speaking Prime Ministers, Lloyd George being the other. Billy Hughes was honoured by being featured on an Australian postage stamp in 1972.

Wartski's Jewellers

Morris Wartski arrived in Bangor in 1865 as a Polish refuge and opened a draper's shop. His two sons, Charles and Harry, moved to Llandudno to expand the business with a diamond merchants and antique shop at 33 Lower Mostyn Street and a ladies' outfitters at 101 Mostyn Street, as well as the jewellers at 93 Mostyn Street.

Charles died young, but Harry continued the business and when Wartski's opened their first London shop it had a sign over the door proclaiming 'Wartski's of Llandudno'.

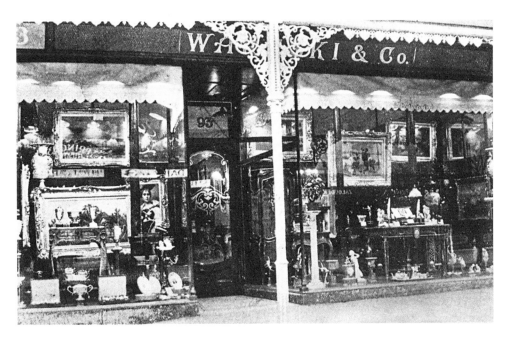

Wartski's original shop at 93 Mostyn Street.

Wartski's most notorious customer was the 5th Marquess of Anglesey, who had a penchant for clothes, furs, jewels and the theatre, and at one time owed the jeweller's nearly £27,000 – well in excess of £1.5 million today!

Wartski's was famous for buying a vast amount of Fabergé after the Russian Revolution, including the Tsar's personal jewellery from the Soviet Government. These treasures were displayed in the Llandudno shop even before they went on exhibition in London. In fact, the story is told that Harry Wartski brought some of these items from London to Llandudno in his suitcase and as he stepped off the train at Llandudno station the case flew open, scattering priceless jewels all over the platform.

Warrants and Coats of Arms held in the Llandudno shop included that of King George V, Queen Mary, Queen Elizabeth the Queen Mother, and the present Queen. Harry Wartski sadly died in the shop a week before he was due to retire in 1972.

In 2011, Wartski's made the Duchess of Cambridge's wedding ring.

Richard Williams

In 1969 former bank clerk Richard Williams, of Dolarfon, Roumania Drive, took on the establishment by printing his own Welsh banknotes, which led to the government abolishing the blue 2d tax stamp which had been embossed on every cheque and banknote up until then.

Mr Williams printed £1 and 10/- notes on his own presses in the old Co-op shop building in Deganwy. He then went to the Liverpool Stamp Office to get them legalised with the Royal Crown. Sometime later, the government apologised for having illegally endorsed a promissory note for less than £5 and invited him to return his Welsh money for a refund. This resulted in bank note collectors all over the world wanting to buy his money.

Richard Williams with some of his Welsh banknotes, hot off the press.

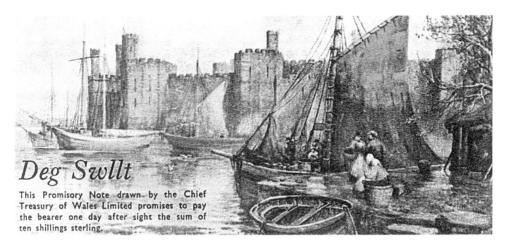

Deg Swllt

This Promisory Note drawn by the Chief Treasury of Wales Limited promises to pay the bearer one day after sight the sum of ten shillings sterling.

A ten bob Welsh banknote showing Caernarfon Castle.

Mr Williams then printed one note for £1,000,000 and when he presented it to the Stamp Office they objected until he pointed out that it was for more than the £5 which had been stipulated. The London establishment eventually conceded, upon which he stamped it 'Cancelled' then put it up for auction in London. It is believed he made several hundred pounds for the first and last government-endorsed Welsh million pound note.

He was involved in a long legal tussle with the banks, claiming that he had invented a computer numbering system for cheques. He lost!

Next he started up a computer school in the then empty Marle Hall, which had been a convalescent home. The computer he was using was very large – filling one of the most spacious rooms in the hall. Having just installed the machine, it became apparent that there was a problem with the lease of the hall, and so he had to have the computer taken out again.

Finally, he set up a workshop in the garage of his house and employed workers to dismantle the computer to recover the many gold-plated items in the machine, to make them into jewellery.

Ted yr Ogof

The Jones family – Miriam and Isaac from Amlwch – lived in a cave on the West Shore for thirty-seven years. It is now the garage of St Petrock's, Marine Drive. They reared fifteen children including three sets of twins. In 1877 they were faced with being evicted to make way for the new Marine Drive but refused to move until the Marine Drive Company gave them a cottage. At the new house on Marine Drive, they put up a shed from which Miriam provided refreshments for passing visitors. Known as Miriam yr Ogof (Miriam of the Cave), she died aged 91 in 1910.

Their great-grandson Ted Jones, a larger than life character known as Ted Rogo (an anglicised and corrupted version of yr Ogof), was a boatman, probably one of the last, who fished and offered trips to the lighthouse for the visitors in the 1950s and '60s. He was often seen mending his nets on the Promenade and sold his catch from a handcart in Market Street. There is a memorial to him on the Promenade near to where he died.

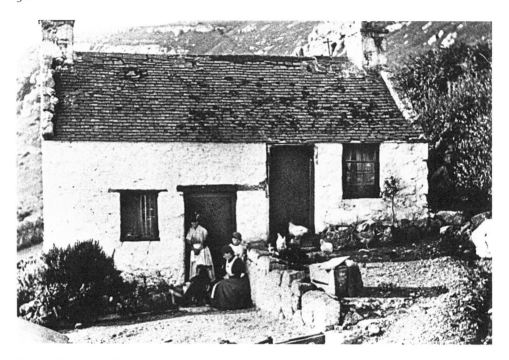

Miriam Yr Ogof and family at her cottage on Marine Drive, West Shore.

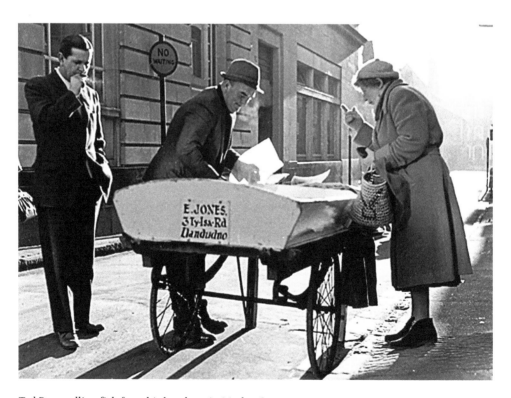

Ted Rogo selling fish from his handcart in Market Street.

5. Public Buildings

The Old Police Station

In 1854 the Llandudno Improvement Act was passed and the Town Commissioners were appointed to undertake the tasks now performed by today's Town Council. A Magistrates' Court was held in the first Town Hall, Capri at 70 Church Walks. This was initially to cope with the large number of Llandudno residents refusing to pay their first town rate demand of half a crown (12.5p) in the pound, levied in 1855.

The Commissioners appointed an Inspector of Nuisances, paid him 16s (80p) per week and built a small lock-up behind 67 Church Walks at a cost of £485 3s 5d for him to incarcerate offenders. This was a low building with two heavy oak doors and no windows. He only lasted a year then they had to appoint another Inspector as a replacement, at the now inflated cost of 18s a week!

In 1857, dissatisfied with only one Inspector to police the rapidly developing town, the great and the good formed the Llandudno Association for the Prosecution of Felons – a club which offered rewards for information leading to convictions.

Llandudno's first police station and court off Upper Mostyn Street.

By this time the Caernarfonshire Constabulary had been formed and the Town Commissioners were hoping that they would be released from the burden of paying their Inspector his 18s per week. They were unlucky and it wasn't until 1874 that the Chief Constable relented and the town got its own sergeant and two constables. A lock-up and police station was built in Court Street in 1867 and in 1872 a Magistrates' Court was added. It is now a private house, but you can still see two barred cell windows.

Railway Station

In 1858 the St George's Harbour Company built a rail line to Llandudno to link up with the Holyhead mainline at Llandudno Junction. This was a single track affair and as the company did not own any engines, they had to borrow a tank engine from the main line operators at Llandudno Junction. In the winter months when there were fewer customers, they used horses to haul the carriages. If the wind was in the wrong direction, the horses could not manage it, so the passengers had to get out and push!

In 1892 the much expanded station we have now was built and the line from the Junction was twin tracked to mainline standards. There were five platforms with a long, wide road between platforms 2 and 3 which allowed the hansom cabs to line up alongside the railway carriages. Extensive sidings were built, eleven to the west and nine to the east,

DID YOU KNOW?

Llandudno profited from the ending of the Crimean War in 1856, because it led to the markets being flooded with iron. A new business emerged for the iron foundries – the manufacture of highly decorated cast-iron verandas. Many were exported to the Colonies as well as providing canopies for the shops in Mostyn Sreet and the really ornate verandas on the front of some of the hotels on the Promenade, many of which are still there today.

DID YOU KNOW?

The Cocoa House at 66 Mostyn Street opened in 1883 as a Temperance establishment, where working men, their wives and children met to drink cocoa, eat pies and cakes, and sing. Penny dinners were served to the poor. On 23 January 1907 a group of local women were invited to attend a meeting (no men and no press admitted), where they formed the Llandudno Branch of the National Union of Women's Suffrage Societies (NUWSS) to campaign peacefully for Votes for Women, the first such society in Wales.

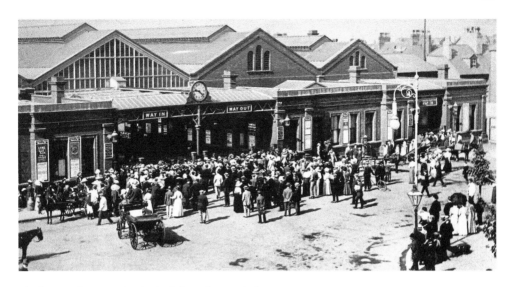

The busy railway station in the Edwardian period.

with a turntable to turn the engines around. Trains arrived every four minutes during peak excursion periods. At the insistence of Lord Mostyn, the station had a massive canopy roof – the largest in North Wales – to stop the smoke polluting the town. Alongside was a large goods yard and almost all the goods to service the town came through it.

To cater for businessmen who lived locally, there was a Club Train which left at 7.40 a.m. every week day to take them to Manchester. Their newspaper of choice would be awaiting them, breakfast was served as they sat in their personal seat, and they had a locker for their pipe and tobacco. They would catch the train back at around 4 p.m. and be home in time for dinner.

DID YOU KNOW?

In 1898 an electric generating station was built to power fifty arc lamps to light up the larger, open areas of the town such as the Promenade. This development was ahead of its time – it was proposed to use rubbish from the town to generate electricity. The reality was that in those days people threw little combustible material in their bins, mostly ashes from their fires, so coal had to be reverted to for most of the power generation. Later, electricity was supplied for commercial and domestic use and the new electric trams.

6. Hotels and Convalescent Homes

The Craigside Hydro

In 1882 the Mostyn family, short of cash, put up for auction plots of land then occupied by Bryn-y-Bia Farm at Craigside, adjacent to the Little Orme. Most of the plots were bought for the building of the Craigside Hydropathic Establishment by Mr John Smith of Limpley Stoke, near Bath, where he had, from 1876, run a similar Hydropathic Establishment. The building was completed in 1888 with Russian, Turkish, Needle and Spray baths as well as seawater plunge baths. Massage was given by either a man or a woman, according to choice. There was also a resident physician, John Miles Chambers, the brother-in-law of Mr Smith.

The hydro boasted accommodation for 240 guests in 163 bedrooms, making it the largest such establishment in Wales. With tennis being very popular they built a vast covered tennis hall across the road to allow guests to play when it rained.

Its heyday was the Edwardian era, and the First World War severely impacted upon the business. By 1937 it was known locally as a white elephant – the demand for

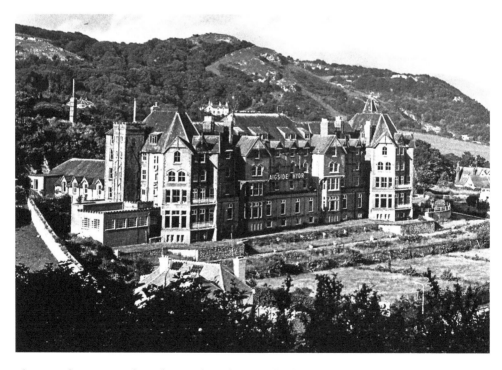

The magnificent Craigside Hydro Hotel overlooking Llandudno Bay.

hydros had passed. It was then that Joseph Kendall-Jackson was invited to take over running the hotel. Under his management and later ownership its fortunes turned around.

Looking to the future was Lawson's Coaching Company which, in the pre-war period, ran an open-sided Charabanc from Glasgow, with customers staying for just one week in the hotel. Mr Kendall-Jackson took an inspirational step by building up a business based on coach tour customers. Business boomed in the 1950s and '60s until cheap foreign holidays started to eat into the hotel trade in the United Kingdom.

The hotel's most famous guest was Princess Margaret, who had lunch there in May 1951 while attending the annual conference of the National Union of Teachers.

In the late 1950s the tennis hall and garages were converted into an ice-skating rink and for a short while it was the venue for ice-dancing shows. Between 1970 and 1974 the building was leased to Hotpoint Ltd of Llandudno Junction and was used for the production of vacuum cleaners.

Finally, in 1974, a property company made an offer for the hotel and its extensive grounds, which the Kendall-Jackson family could not refuse. In 1975 it was demolished and eventually twenty-one houses were built on the site with another twenty-three across the road.

DID YOU KNOW?

The Marble Arch, a tunnel between the shops leading from Madoc Street to the present day St Mary's Road, led to marshes and scrubland popular with wild fowlers stretching to the West Shore. Later, St George's Hotel used the land as a vegetable garden entered between limestone gateposts and an arch. The limestone looked like marble and that's how it got its name.

Grand Hotel

The 156-room Grand Hotel was the largest in North Wales when it was built in 1901 for Frances Doyle, on the site of the old baths, Reading Room and Billiard Hall, which had been opened there in 1855, before the first pier was built. The baths were later extended and in 1879 became the Baths Hotel, but this was demolished in 1900 to make way for the new luxury Grand Hotel with its spacious reception rooms and a large ballroom. It has excellent sea and mountain views from its balconies. It was, and still is, very popular with its guests.

During the Second World War it was taken over by civil servants from the Inland Revenue, evacuated from London between 1940 and 1945.

The hotel register reads like 'Who's Who?' as so many famous politicians and entertainers came to stay. Top of the list must be Winston Churchill; in 1948 he paid his last visit to Llandudno for the Conservative Party Conference, at which Margaret

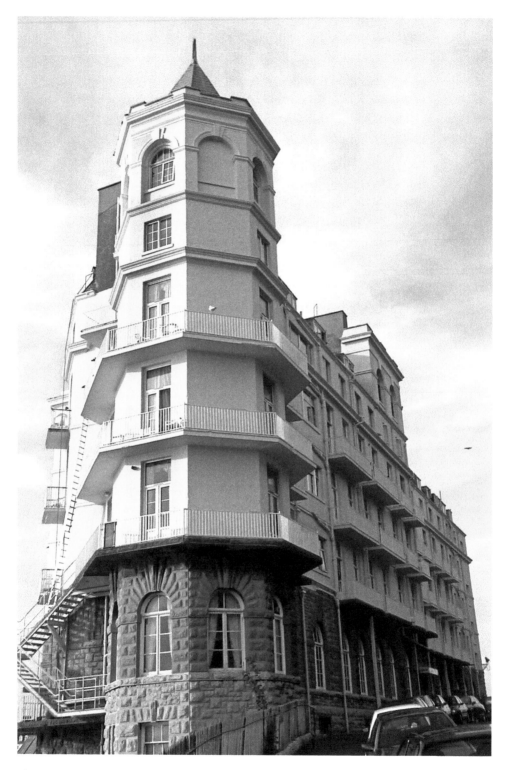

The Grand Hotel dominates the Great Orme end of the bay.

Winston Churchill with his wife and Anthony Eden leaving the Grand Hotel for the Party Conference in the Pier Pavilion, 1948.

Thatcher began her political career. Others guests included Clement Atlee, Anthony Eden, Lloyd George, Ted Heath, Sir Oswald Mosley and Harold Wilson. The Beatles stayed here in 1963 when they were appearing at the Odeon.

The hotel has featured in a number movies, including *The Card* starring Sir Alec Guinness and *Yanks* starring Richard Gere.

DID YOU KNOW?

When Llandudno was a growing town, the need for ice for catering became a problem. The answer was to import ice from America! The Wenham Lake Ice Company was set up to harvest the ice from Wenham Lake, Massachusetts. The blocks of ice would be carried across the Atlantic in ships' holds to Liverpool and from there brought to Llandudno in insulated wagons. The ice was so pure, it was claimed, that it was safe to put in drinks.

Lady Forester's Convalescent Home

Originally opened in 1904 as Lady Forester's Convalescent Home, this splendid building occupies an elevated 18-acre site in Craig-y-Don, with panoramic views across Llandudno and out to sea.

Lady Forester was born plain Mary Anne Ricketts but she was no commoner, her father was a Viscount and her first husband, Colonel David Ochterlonay Dyce Sombre, was enormously wealthy and left her his entire fortune in his will.

In 1862 she married the 3rd Baron Forester, George Cecil Weld, an Army General, Comptroller of the Royal Household, MP for Wenlock (1828–74) and Father of the House of Commons. When he died in 1886 she decided the estate could spare the odd three-quarters of a million pounds to endow charitable works in his memory. Following Lady Forester's death in 1893 the charity finalised plans for a hospital in Shropshire and a convalescent home in Llandudno. The Forester family owned quarrying and iron-making works in Shropshire and erected the Llandudno facility to enable ill and injured workers to recuperate in healthy and attractive surroundings.

Llandudno certainly wasn't chosen for ease of access – the train journey from Much Wenlock to Llandudno required three changes! In 1905 the fare was 16/11 (£48.50 today).

The first sod was cut in 1898, building commenced in 1901 and the home was designed to accommodate fifty residents. It was completed and opened in 1904. It was constructed in what was described as 'a homely manner' to make residents feel as comfortable as possible.

The north wing housed female convalescents, the south wing male convalescents and the central section the matron and her staff. The resident staff were a matron, two nurses, cook, laundress, linen maid, five housemaids, kitchen maid, scullery maid and an assistant engineer.

The gardens were laid out with lawns and thousands of trees and shrubs. There was a kitchen garden which supplied vegetables and some fruit. Gardeners also helped with lighting fires in the house and ensuring the boiler didn't go out. They lifted patients and helped men with bathing and shaving when necessary, and could be relied upon to do shopping for any patients not yet well enough to go out.

In 1914 the matron was Miss K.E. Elphick, and her salary was £65 per annum (£3,237 today). She also enjoyed the benefits of 'sufficient meat, drink, washing and fuel, and shall reside at Lady Forester's with the exclusive use of a bedroom, and sitting room so far as the same shall not be required by trustees for meetings'. Miss Elphick was highly regarded by her patients – one described her as 'just like a mother to us all' on a postcard he sent home.

Lady Forester's served as a Military Convalescent Home during the First World War, staffed at least partly by members of the Voluntary Aid Detachment (VAD) who worked as ambulance drivers, nursing assistants, chefs and in any other capacity required.

Records show that at Christmas 1914 each patient and member of staff received a box of chocolate from Cadbury's, as did all military and naval patients and the staff caring for them that year.

After the war it reverted to being a convalescent home but was used again for military personnel in the Second World War and after that returned to civilian use until 1971, when it became a private medical centre. In 2007 it was bought by St Dunstan's and opened in 2011 under the new name of the Blind Veterans UK.

DID YOU KNOW?

The Empire Hotel, at the top of Upper Mostyn Street, was built in 1854 as Llandudno's first modern department store. It had a chemist, a grocer and an Italian warehouse. Run by a 23-year-old Denbigh man named Thomas Williams, he was possibly Llandudno's first entrepreneur. He published a *Visitor's Handbook* in 1855 in which were advertised the commodities that the chemist sold, including Atkinson's Bear Grease for gentlemen's beards, Dr Erasmus Wilson's Hair Wash, gunpowder, Oriental Toothpaste, fire insurance, Black Draught Family Medicine, Llandudno Bouquet Perfume and fresh German leeches.

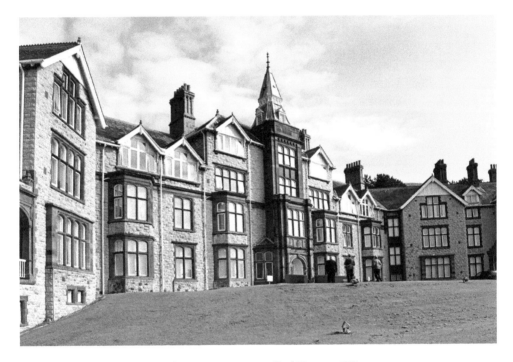

Formerly Lady Forester's Convalescent Home, now Blind Veterans UK.

7. Places of Worship

St Tudno's Church

Sometime during the reign of Maelgwyn Gwynedd, known as the 'King of Gwynedd' (490–549), a Celtic missionary, Tudno (pronounced Tidno), established a cell on the Great Orme. He may have inhabited a cave at first but later created an enclosure or llan. Tradition has it that the community gathered around this llan and this was the beginning of Llandudno. The church we see today is much modified, but some walls have been dated to the twelfth or thirteenth century, while the others are mostly fifteenth century. In 1849 it was stated in a guidebook (*A Ramble at Llandudno*) that the church was sparsely attended and the clergyman from Conwy and his clerk had to make a 10-mile round trip to hold afternoon services. In the winter, they were often the only attendants. In 1839 St Tudno's roof was blown off during a massive storm and the church was replaced in 1840 by St George's in Church Walks, mainly for the Welsh-speaking population. Fortunately, the main timbers of St Tudno's roof survived until it was restored at a cost of £100 in 1855.

Outdoor services are still popular in the summer, conducted from a stone pulpit erected in the churchyard in 1914 to cater for the large number of soldiers who were stationed in the town at the start of the Great War.

The house across the road, known for years as the Old Rectory, was in fact the Curate's Glebe Farm – Dolfechan.

In the old graveyard, most of the tombstones are made of local limestone, which has not weathered well. The adjacent Municipal Cemetery was established in 1903, with its own Cemetery Chapel for those of non-conformist denominations. At the beginning of

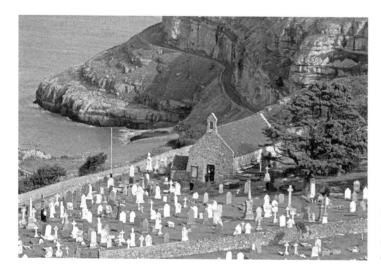

St Tudno's Church nestles on the Great Orme, above the cliffs overlooking the sea.

the nineteenth century, slate became the favoured material for the gravestones and these have retained the clarity of the inscriptions.

St Tudno is the Patron Saint of Llandudno.

Tabernacle Chapel

The great rise in religious non-conformism of the nineteenth century came to Llandudno with the opening of Ebeneser Chapel for Calvanistic Methodists in 1814 and Tabernacle Chapel for Welsh Baptists in 1815. The site of Tabernacl in Upper Mostyn Street dates back to the pre-enclosure era of Llandudno. The only Anglican Church then was St Tudno's, situated remotely on the Great Orme. The majority of residents in the town were followers of non-conformity and abstinence. In 1835 the Llandudno Temperance Society had a membership of 250, approximately one-third of the population.

The 1860s saw a surge in the building of churches and chapels in the resort. Tabernacl was rebuilt in 1876 to cater for both Welsh and English followers and a schoolroom was added in 1902. It is the only chapel in the town with a full-sized, heated immersion baptismal font. This is normally hidden under the floor of the 'sett fawr', where the minister preached and the elders sat.

The most famous minister was the Revd Lewis Valentine, who was appointed in 1921. He was a Welsh Nationalist who, along with two others, set fire to a contractor's hut on the building site of the new RAF Bombing School (later to become RAF Penrhos) at Penyberth, near Pwllhehli, on 8 September 1936. Along with his co-conspirators he was sentenced to nine months' imprisonment at the Old Bailey. He was welcomed back to his ministry by his congregation, who had been supportive of him throughout the whole affair.

He was one of the founders of the Welsh Home Rule Army which later became Plaid Cymru (the Welsh Nationalist Party), of which he was elected President.

Tabernacle
baptismal pool.

Masonic Hall

The Masonic Hall in Upper Mostyn Street is one of those gems that are only occasionally seen by members of the public, on open days.

When Llandudno town was being built in the 1850s, the only Masonic Lodges in North Wales were at Holywell and Holyhead. It was in 1858, with the arrival of the railways and an increasing population, that Brother Boden petitioned the Grand Master for the formation of the Tudno Lodge, No.1057, in Llandudno. This was granted on 23 July. The Charter Master was Mr William Henry Reece, who had moved to Llandudno from Horningsham in the Cotswolds for the health of his daughter, Maria. All thirteen founders were incomers to the town.

After several years using various meeting places it was decided that there was a need for a tailor-made temple. Fundraising ensued and by October 1867 it was built and opened in its present location at a cost of £2,022. The most interesting feature is that it was designed to have shops on the ground floor to provide an income for the upkeep of this first Masonic Hall in the province, built specifically for Masonic purposes.

In 1839 a hurricane blew the roof off St Tudno's Church on the Great Orme. The construction of the new St George's Church was started in 1840, while St Tudno's was left roofless. In 1855 William Henry Reece offered to pay the whole cost of the restoration. It was, he said, a thank-offering for the restoration of the health of his daughter. He had two gavels crafted from some of the timbers of the church, which are still on display in the Masonic Hall.

Advert for the Masonic Hall, Upper Mostyn Street, opened in 1867.

Interior of the Masonic Hall.

In 1895 a venture was organised by a committee of women to open Llandudno's first soup kitchen at the rear of the Hall – a reminder of the appalling poverty which was a regular winter feature of the town. They offered a bowl of soup and a lump of bread for those who could afford the one penny to buy it. The ladies also gave gifts of coal, bones, vegetables and money. Soup kitchens were still a feature of the town right up to the Second World War. Sadly, today we have food banks.

Church of Our Saviour

The Church of Our Saviour was built in 1911 for the Church in Wales. It was constructed of fine St Bees Head Sandstone and was consecrated by Bishop Watkin Williams of Bangor on 30 July 1912. At the same time, he dedicated a new finely decorated marble font. A plaque reads: 'This tablet records the fact that the font in this church was the gift of children in memory of Lewis Carroll (C.L. Dodgson), the author of 'Alice in Wonderland' and a lover of Llandudno.' The bishop had been a former student of Dodgson at Christchurch College, Oxford.

An interesting feature in the church, partly hidden, is a sixteenth-century Spanish stained-glass window which had previously been installed in a church in the Netherlands. It was given by Sir Thomas Hughes Neave, 5th Baronet, of Llandulas near Amlwch on Anglesey in memory of his brother, Major Arundell Neave, who was killed at Ypres on 21 February 1915 while serving with the 16th King's Lancers. There is little doubt that the window, which depicts Jesus carrying the cross, was rescued from a church which had been bombed during the war.

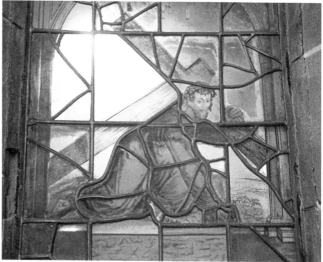

Above left: Church of Our Saviour, West Shore. The marble font is dedicated to the memory of Lewis Carroll.

Above right: The medieval stained-glass window at the Church of Our Saviour.

DID YOU KNOW?

In the early part of the nineteenth century, there was a major upsurge in non-conformism. Llandudno had its share – Baptists, Methodists and Presbyterians, both Welsh and English, came to set up their chapels to save the heathens. The most unlikely were the Mormons or Latter Day Saints who, in about 1845, arrived in the developing town. Setting up in the garden of a house, they congregated in the evenings to conduct public services. A local couple, Peter and Elizabeth Hughes, were so inspired by the missionaries that they followed them back to Salt Lake City. Their Llandudno-born daughter, Martha Maria, became the first female to be elected to the United States Senate.

Duke of Clarence

Following the death of Prince Albert Victor aged 28, Duke of Clarence, in 1892, allegedly caused by Influenza, Lady Augusta Mostyn wrote to the bereaved family offering that a new church to be built in Craig-y-Don should be dedicated as the Duke of Clarence Memorial Church, now St Paul's. It was intended to cater for English visitors to this fast-growing area. Lady Augusta may have been angling to establish a Royal connection with Llandudno.

Prince Albert Victor was the grandson of Queen Victoria. An inscribed memorial stone was laid in 1895 by the Duchess of Teck, accompanied by the Duke and their daughter

The interior of St Paul's Church,
Craig-y-Don.

Princess Mary, who had been engaged to Albert Victor. She was later to marry his younger brother George, who became King George V.

The church was completed in 1901, with the chancel being the gift of Lady Augusta. It was consecrated by Bishop Alfred George Edwards, but no members of the Royal Family were present.

There had been a scandal in London in 1889 regarding a Cleveland Street homosexual brothel. Telegram boys working for the General Post Office confessed that they supplemented their meagre pay by providing services to the gentry and others of a higher order. The police kept the premises under observation and discovered that Lord Arthur Somerset, equerry to the Prince of Wales, was a regular visitor. Had the case come to court, Prince Albert Victor would also have been named as a visitor. Due to a delay in proceeding with the matter, the birds had flown. The man who ran the establishment, Charles Hammond, fled to France, followed by Lord Arthur. Neither man ever returned to England. Prince Albert Victor was sent to India on a lengthy tour of duty, while in the ensuing court cases involving the 'rent boys' they got off with light sentences.

There were suggestions that Prince Albert Victor had been blackmailed by several prostitutes. His untimely death must have been a huge relief to the Royal Family – they knew he was not King-making material. It has been suggested that he had in fact died from syphilis, possibly helped on his way by the royal doctors. The scandals were covered up by the establishment and not repeated in the English newspapers; but in French, American and Welsh papers the matter was discussed openly.

Whether Lady Augusta knew about these goings-on we shall never know. Ever since, the church has been known only as St Paul's, while nearby Clarence Drive still exists.

8. Private Houses

Cwm Howard Farm

Cwm Howard Farm is one of the best kept secrets in Llandudno – surrounded now by an estate of council houses, it is very difficult to see.

It is probably the oldest building in the township, dating back to Good Queen Bess. There are references to it in a lease dated 1539 from the Bishop of Bangor. The farmhouse is Elizabethan with many original timbers, particularly around the fireplace. There is an extension to the right, which was possibly added around 1700 to provide additional accommodation and a bake house. The farm has its own duck pond.

It would have been run by tenanted yeoman farmers or lower gentry. Set in around 80 acres of very fertile land, it seems to have been acquired by the Mostyns about 1800. Along with the adjacent Maesdu Farm, Cwm Howard was one of the largest in the area. Most farms were just smallholdings that disappeared as Llandudno was built over them.

Sunnyhill, Craigside

Sunnyhill was built in mock-Tudor style around 1880 by Mr Joseph Broome, a wealthy Manchester businessman, at a time when Llandudno was just being developed as an important seaside resort. With commanding views across Llandudno Bay it was the first major building at Craigside. In 1892 Joseph Broome became the High Sheriff of Caernarfonshire. A keen horticulturalist who specialised in orchids and other greenhouse

One of Llandudno's best-kept secrets: Cwm Howard Farm.

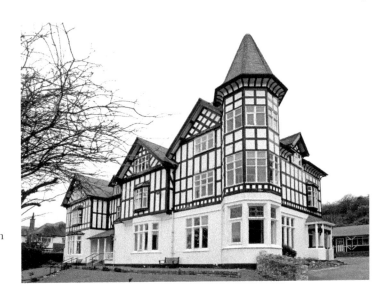

The imposing mansion Sunnyhill, Craigside, built in mock-Tudor style around 1880.

plants, he published many papers on the subject. He was also a generous supporter of the town's May Day – providing flowers for the May Queen's Coronation and a new shilling for every child who took part – and there could be hundreds!

In 1914 Sunnyhill was bought by the Nott Lewis family and became the famous Arnhall, 'A high class boarding and day school for girls'. It offered its own gymnasium and detached sanatorium in the grounds. When the original owners retired it was bought by two of the teachers, the Misses Agnes Moffat and Emma Hill.

In view of Mr Broome's support of May Day, it's ironic that in 1926 the parents of Joyce Payne were told by the school that if they allowed her to be May Queen she would have to leave the school. Mr Payne said that as a Councillor and businessman he thought that when he was asked to allow his daughter to be nominated as May Queen it was an honour – she would therefore accept and pursue her education elsewhere. Joyce was crowned by no less a personage than Lloyd George MP, who said that 'it was a great pleasure and privilege to come from the acridities of politics to take part in such a delightful ceremony, full of charm, gaiety, merriment and goodwill!' At this point, his speech was interrupted by laughter and applause. Several nursery rhyme characters appeared in the Queen's Court, most notably Jess Yates (later of *Stars on Sunday* fame) as Little Jack Horner.

In 1935 the school moved to Gloddaeth Hall.

For many years, Arnhall was a Dr Barnardo's Home for orphaned children, and then a home for the treatment mainly of ex-soldiers with psychiatric problems. More recently, it was surrounded by new upmarket houses and finally demolished, but rebuilt with an external appearance very close to the original building – containing luxury flats.

Bodlondeb Castle

I'm sure many of you will have looked at Bodlondeb and wondered how such a strange piece of architecture came to be built on Church Walks. Well, it was built in 1897 at huge cost by Thomas Davies, the son of the owner of St George's Hotel. It was thought that

at some point, he had come into contact with the Prince of Wales, who had expressed the desire for a 'Castle in Wales'. The interior contained many tons of imported marble and stained-glass windows illustrating the coats of arms of the real Welsh princes. The story goes that the actual Prince of Wales only ever visited 'his castle' once and, given the reputation of the Prince of Wales, was shocked and dismayed to find that it wasn't in the least bit secluded. He simply couldn't understand why anyone would have thought he didn't require extensive grounds surrounding his hideaway. Bodlondeb was known for many years as 'Davies's Folly'. It became a school, firstly for boys and later for girls. It was requisitioned as a military hospital during the First World War. From 1931 it was a Methodist holiday home and finally, more recently, converted into luxury flats.

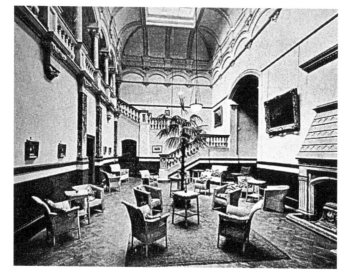

The main reception area in Bodlondeb Castle.

Bodlondeb Castle, Church Walks, built in 1897.

Villa Marina

In 1936 the Villa Marina was built at Craigside as a holiday home, at a cost of £30,000 (well in excess of £1 million today) for Mr Harry Scribbans. He was a Birmingham baker who had made a fortune through manufacturing slab-cake for the government for soldiers in the First World War and also his own-brand Swiss Roll. Villa Marina was designed by his friend, Birmingham architect Harry Weedon – one of Odeon owner Oscar Deutsche's favourite architects. The house is meant to represent an ocean liner when seen from the beach – it has curves, balconies, rails and rectangular chimneys in place of funnels.

Sadly, Harry Scribbans died before it was completed and his wife, Ada, hated it so much that she sold it for £5,000 over a meal at the St George's Hotel. It became a convalescent home and for a short time a hotel before being sold for around £650,000 in 2012. At last it became a private house as originally intended.

Having started out as a baker's boy, Harry Scribbans owned Little Aston Hall in Staffordshire and reputedly fifteen Rolls-Royces. When he died he left £2.5 million (about £92.5 million today) and the interest on £1 million to his wife – on condition she didn't remarry. But obviously, romance was more important to Ada than riches as she did remarry and forfeited her right to the money!

Ada Scribbans outside Villa Marina.

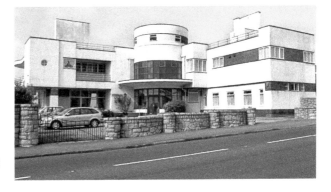

Villa Marina, Craigside, a fine art deco villa built in 1936.

9. Entertainment

Happy Valley

What we now know as the Happy Valley had been a farmer's field with substantial quarrying nearby. The site had the advantage of being a natural amphitheatre but there was no formal stage.

In 1872 Mr Round's Promenade Band came here and gave alfresco performances. In 1887, to mark Queen Victoria's Jubilee, Lord Mostyn closed the quarries and gave the land to the town as a permanent park. In 1886 Mr Joe Perry took over the plot with his Happy Valley Minstrels. A primitive stage was constructed and a bell-tent put up for use as a changing room. Joe Perry performed there with his troupe for nineteen years. He died in 1904, but his troupe struggled on for a further year. In 1906 one of his players,

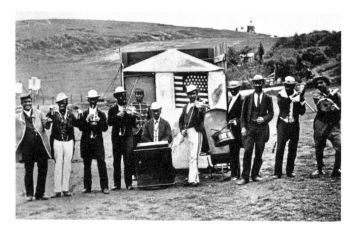

Perry's Happy Valley Minstrels.

Cowell's Queeries at the Happy Valley Theatre in 1930.

Will Churchill, who had been with Joe for fifteen years, decided he would set up his own minstrels. A stage was erected in the form of a castle, with the luxury of dressing rooms. The entertainments were mainly songs, ballads, ditties and verses.

In 1930 Roy Cowl took over with his 'Cowl's Queeries', so ending the tradition of blacking-up. The show had ladies in it, so dancing was added to the mix. In 1933 a new stage and facilities were built and in 1936 Charles Wade with his Concord Follies and Gay Wayfarers took over and continued until 1954. The next incumbent was Waldini with his Gypsy Girls Band; his strapline was 'If wet in the Town Hall'. In 1960 another Scotsman, Alex Munro, took over for the final years with general entertainment and talents shows, which were still well attended. What finally killed it, apart from the change in people's tastes, was the building of the Great Orme Cabin Lift. This created so much noise that the performers had to pause when the cabins went into the station with an almighty roar. Alex finally gave up in 1987. The theatre became derelict and eventually the target of arsonists and demolition by the council.

Camera Obscura

The Llandudno Camera Obscura is one of three iconic attractions which have been features of the resort since Victorian times, the others being the donkeys on the beach and the Punch and Judy show. In the words of Erasmus Darwin: 'Lo, here a camera obscura is

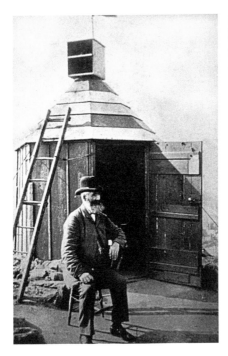

Above left: Lot Williams and his Camera Obscura on Camera Hill.

Above right: The late Jackie Shields rebuilt the attraction after it was destroyed by fire; here he is operating the camera.

presented to thy view... if thou art perfectly at leisure for such trivial amusements, walk in and view the wonders of my enchanted garden.'

First built in 1859 by 18-year-old Lot Williams (1849–1919), one of Llandudno's first postmen, it is perfectly positioned on the heights above the Happy Valley, on what is still known as Camera Hill. Essentially, it is a darkened room with a white table, about 4 ft round, which acts as a screen for views picked up by a lens and mirror mounted in a turret on the roof.

Victorian visitors were able to see moving pictures, in colour, of a panorama of the town and from Liverpool Bay over Llandudno Pier across to the Little Orme, also Penmaenmawr across to Anglesey. One of the vicarious delights for viewers was to spy on the unwary courting couples cuddling in the Happy Valley below!

It was operated by Lot's relatives until 1964, only to be destroyed by a fire caused by vandals in 1966. Several years later Jackie Shields, a local taxi-driver and camera obscura enthusiast, rebuilt it on the same site. It is one of just seven such instruments remaining in Britain.

Pier Head Pavilion

The new pier opened to the public in August 1877 and a temporary bandstand was built at the pier head. From the start, the plan had been that a proper pavilion should be erected there. Tyler's band was engaged to entertain the crowds; he had seven bandsmen and women. They wore a uniform of trousers, frock coats and pillbox hats. They played 'selections that were happily chosen and artistically executed' during 1877 and 1878 (*North Wales Chronicle*, 3 August 1878). There were over 30,000 promenaders in the first season.

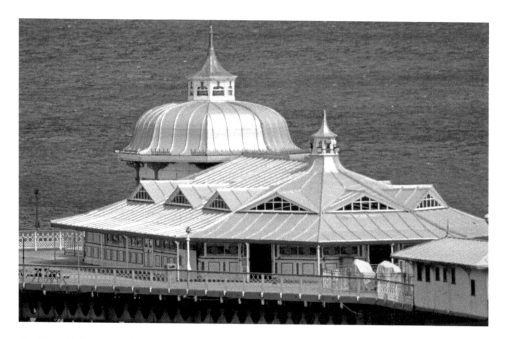

The beautifully restored Pier Head Pavilion.

The Pier Head bandstand was enlarged and improved by providing a canvas roof over the audience, and later became a fully functioning pavilion. Around 1900 it was the venue for light entertainment – Arthur Sutcliffe's troupe being very popular. Clarkson Rose, who later brought his 'Twinkle' show to the Pier Pavilion, recounts how he heard Arthur sing 'Penelope loved a Pierrot on the Portobello Pier' at Llandudno in 1904. According to Clarkson, Arthur spent many years on Llandudno Pier – in fact he was still there in 1923 performing shows daily at 3 p.m. and 8 p.m. His 1921 programme, price two pence, has a mirror image photograph of himself giving the impression that he is one of twins! He described his show as being 'Refined, Versatile, Original'.

In 1938 John Morava took over the Pier Head Pavilion with a small variety orchestra, which he augmented at Sunday evening concerts with famous leading vocalists. He continued the Pier Head tradition of concerts during the day. The show was interrupted by the Second World War when part of the pier decking was removed to stop enemy invaders. Opening again after the war, Morava's tenure lasted until 1974, when his orchestra was disbanded and the Pier Head Pavilion became an amusement arcade, which it remains to this day.

Pier Pavilion

Llandudno's Pier Pavilion was the premier venue for many of the best entertainments from the Victorian period right up to its heyday in the 1950s; shows were listed in the national press alongside Blackpool and other famous resorts.

The Pier Company had built and opened the new pier in 1877. A bandstand was put up at the seaward end which was quite soon converted into a modest pavilion. With the demand for musical recitals increasing, work on a new, bigger pavilion at the shore end started in 1881. It was a 2,200 seat, three-storey structure in typical Victorian style, built largely of cast iron with superbly detailed decorations. Unusually, it had two entrances, the main one from the pier level to the stalls and another to the balcony from Happy

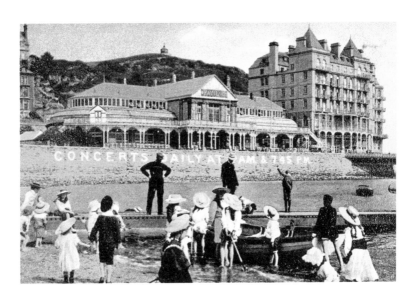

Llandudno Pier Pavilion in the Edwardian era.

Valley Road, behind the theatre. The basement contained what was claimed to be the largest indoor swimming pool in Britain.

Just before it was due to open in the spring of 1883, a major storm caused severe damage to parts of the plate-glass roof, resulting in it being replaced with lead. This delayed the opening until September 1886. The Pavilion was 204 ft long by 84 ft wide and 104 ft high and essentially designed as a concert hall.

Adjacent to it was the Egyptian Hall complete with hieroglyphics on its walls – the venue for Professor Walter Beaumont's novelty underwater swimming display in a glass-sided tank. Also, one season, the Doll Lady, aged 21 but only 25 inches tall, appeared – punters were invited to 'Admire her Beautiful Costumes, Marvel at her Magnificent Jewellery and Appreciate her Rare Intelligence'.

The swimming pool wasn't popular so it was closed down and later, when the Baths Hotel was demolished, the debris was used to fill it in. In 1899 Mr Brett opened the Bijou Theatre Company there. My grandmother remembered going to see panorama lantern slide shows and silent films were shown in the 'Pier Picture Palace' until sometime in the 1930s. It then became Tuson's popular amusement arcade with slot machines and bumper cars.

In 1877 Jules Riviere, a former French Army musician, was appointed to conduct the seven musicians of the Pier Head Orchestra. In 1887 he took his by now twenty-eight piece Pier Orchestra into the main Pavilion. He conducted the orchestra with a jewelled baton while seated and facing the audience – Sir Henry Wood visited and was most impressed by Riviere's style. A tradition of notable guest conductors including Sir Adrian Boult conducted the by now forty-two musicians and when Sir Malcolm Sargent appeared for several seasons the orchestra was augmented to sixty-five.

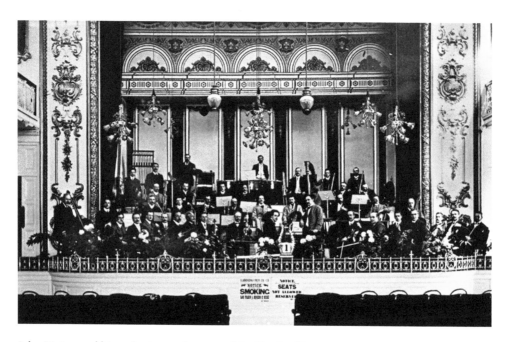

Jules Riviere and his orchestra on the stage of the Pier Pavilion.

In 1936 the Pier Company decided to end the orchestral concerts and make way for variety, but a much smaller orchestra already playing under John Morava at the Pier Head Pavilion survived until 1974.

The year 1936 was the start of the golden age of the Pier Pavilion with the Fol De Rols and a veritable pantheon of famous stars, from Anna Pavlova to Paul Robeson, Vera Lynn to Cliff Richards, and The Beverley Sister, Arthur Askey, Russ Conway, Billy Cotton, Jimmy Edwards, George Formby, Ted Ray and Alberto Semprini in between. It also regularly hosted major political conferences and many notable people attended, including Winston Churchill, Oswald Mosley and David Lloyd George. It is said that it was there that the young Margaret Thatcher, attending a Tory Conference in 1948, decided to take up politics.

In the 1960s the Local Authority considered the Pier Pavilion as a Conference Centre but decided against it. The end was in sight and by the late 1960s it was showing films for the whole season, while the Pier Head Orchestra soldiered on. The business had fallen into the hands of accountants with no real understanding of showbiz. In the 1970s Alex Munro of the Happy Valley Theatre took it on and in 1972 put on its first ever pantomime. But the decline in audience numbers continued and in 1983 the Pier Pavilion was sold for £10,000 to the company which owned the Great Orme Cabin Lift. They put on a new summer show but audiences failed to materialise and in 1984 the final curtain fell.

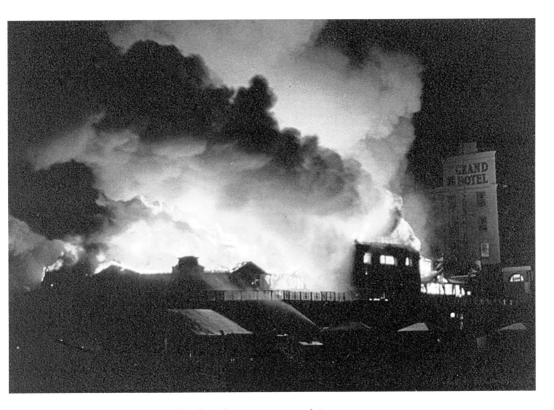

The Pier Pavilion is consumed by fire after an arson attack in 1994.

But it was not quite over – the vast basement was converted firstly into a Ghost Train and 'Vintage Car around the World' ride; then later into Llandudno Dungeon – a sort of walk-through horror waxworks show. There were some gruesome aspects of history: the Great Plague, a Victorian London Street with Sweeney Todd's barber's shop, and a full-size guillotine! It was quite successful for a few years but eventually closed in 1990.

In 1992 ownership passed to another company which announced its intention to restore the building into a Covent Garden-style indoor market. Nothing happened and inevitably, being insecure, in 1994 it fell victim to arsonists and was totally destroyed.

St George's Concert Hall

The St George's Concert Hall was Llandudno's first building for 'holding public concerts, lectures, literary meetings and other gatherings for useful instruction and entertainment', with a capacity for 900 persons. It was built in 1864 by Thomas Owen to provide culture for upper-class visitors to the town. It was unusual in that the ground floor was occupied by shops and entrance to the theatre was through doorways and staircases at either side of the frontage. It opened in 1865 and the first shows were two somewhat obscure comic operas by Mozart, *L'Impressario* and *Marcellina*, performed by the Drayton Opera Company, thus providing the foundation for what became Llandudno's long operatic tradition.

There followed regular concerts which became the pattern for many years. The D'Oyly Carte Opera Company, which was then in its heyday, made frequent visits, playing Gilbert and Sullivan's *The Mikado* and *Iolanthe*. In 1893 the hall was given a complete makeover and in 1903 was renamed the Prince's, putting on plays and musicals. In the 1920s it was

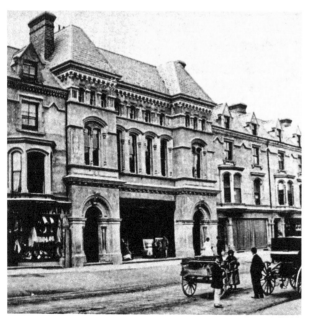

St George's Hall, Mostyn Street.

The spacious interior of St George's Hall.

converted to give silent cinema shows alternating with variety acts. With the coming of the talkies in 1930 variety was dropped and only films were shown. It continued as a cinema until 1957. After that the shop was extended and a café installed in part of the hall. The shop is now HMV, while the hall upstairs currently remains vacant, with its fine ceiling exposed.

Mostyn Gallery

The Mostyn Gallery (Oriel Mostyn), now re-badged as 'Mostyn', has certainly the finest architectural terracotta work in Llandudno. It was made at the Ruabon Brickworks near Wrexham. It is weather resistant and the reliefs showing classical scenes are as sharp today as when they were made in 1900.

The gallery has an interesting history. Lady Augusta Mostyn, who ruled the roost in the Mostyn family (the major landowners in the town) and was a talented photographer and keen on arts and crafts, wanted women to be able to display their work. They were excluded from membership of the Royal Cambrian Academy in Conwy and had

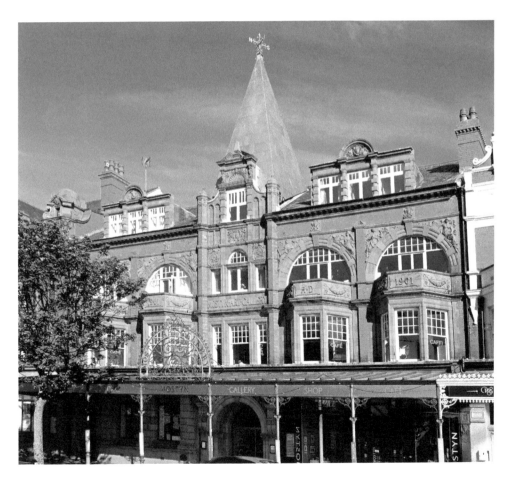

Mostyn Gallery in Vaughan Street.

The new un-Victorian interior.

to exhibit their work in the Conwy Cockpit. Lady Augusta created the Mostyn Gallery primarily for the display of work by the Gwynedd Ladies' Art Society and for training in practical crafts such as needlework and weaving. After Lady Augusta died in 1912 and with the First World War looming, the gallery was turned over to use as a drill hall for recruits to the army. After 1918 it was used for retail, shared by Boots and Debenhams. During the Second World War it was used as a canteen, known as 'The Do-nut Dugout', for American service personnel and was popular with locals who were invited in by the Yanks.

There were plans to turn it into a Synagogue in 1945 but this did not materialise. It was later taken over by Mr Wagstaff, who opened his piano emporium there.

In 1979 it was completely revamped and reopened as an art gallery. This involved bringing the galleries up to modern lighting requirements for the display of sensitive works of art, along with improvements in security. In the event there was a Turner Exhibition which was first class. Many years later the 'Fields' exhibition by Antony Gormley was a great hit, with people queuing up to see it.

Since then it has undergone a £5 million revamp and is now a gallery for contemporary art but also exhibitions of local history and musical recitals.

The Palladium Theatre

The Palladium Theatre (now Wetherspoon's) was built in 1920. It replaced Llandudno's first Market Hall, which was opened by the Llandudno Market Company in 1864.

The Palladium was initially built 'to carry on the business of kinematograph hall, theatre, music hall, opera house, circus and entertainment proprietors etc.'. Kinematograph was an early name for film. The building was designed by Arthur Hewitt, an architect who was also a Llandudno Councillor and, in the Second World War, a Home Guard Commanding Officer. The theatre had 1,500 seats in the stalls and two balconies. It had its own orchestra and offered a blend of drama, variety, musical comedy and ballet. It was in fact only the second purpose-built theatre in the town. One of the stars who performed there was Gracie Fields (1898–1979), who grew up in Rochdale and became a famous singer and actress, making the transition from music hall to cinema films and television.

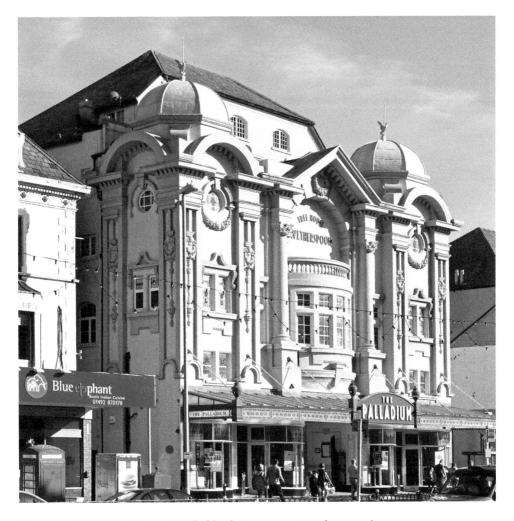

The restored Palladium Theatre in Gloddaeth Street, now a Wetherspoon's.

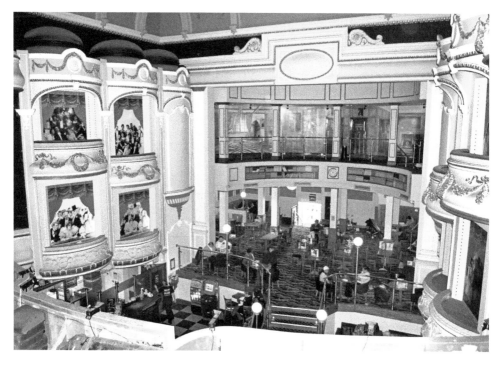

The sensitively converted interior of Wetherspoon's.

Its place in my heart is due to my mother, Joan Parry, appearing aged 8 in a pantomime on its stage in 1923. I have the postcard the manager, Mr Percy Artingstall, sent to thank her. He said, 'No gift can really express how beautifully you have carried out your part in the Transformation Scene which has been a great success, but this little gift [unknown] is an appreciation of your part played so beautifully.'

For many years after the Second World War, it became principally a cinema but in 1972 was split into a Bingo Hall in the stalls with a 600-seat cinema above, the last film ever shown here was *Titanic*. In 2001 the building was sensitively converted by Wetherspoon's into a cavernous pub which still retains many of the original features of the theatre.

Winter Gardens

In 1934 Rochdale-born brothers, Zach and James Brierley, whose family fortune had come from pork pies, acquired the site of a former vineyard on Gloddaeth Avenue. They owned the Cream's Coach Hire Company and needed a new garage, which they built on the site of what is now Ormeside Grange.

Being enterprising, they decided that Llandudno needed a multi-storey car park, which they proceeded to build over the garage. This proved to be unpopular as there were so few cars then and owners were quite happy to leave them parked on the road. So Plan B came into operation and they decided to convert the car park into a cinema because 'the talkies' were just coming in. They hit a snag in that no insurance company wanted to know – a place of entertainment over a garage was potentially lethal! So Plan C evolved –

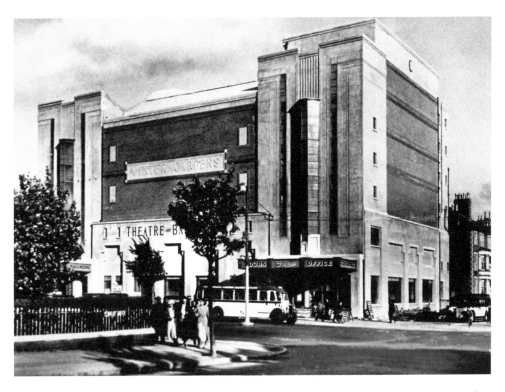

The impressive Winter Gardens in Gloddaeth Avenue, which had a 2,000-seat theatre with a ballroom below.

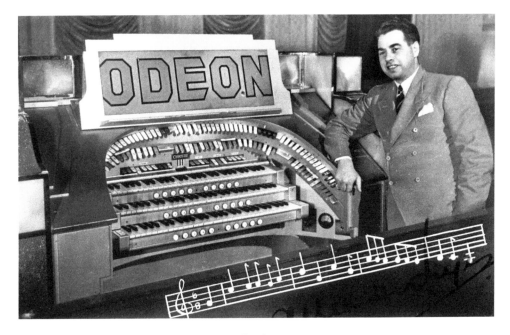

The Odeon's Christie Organ with organist P. Allender Fryer.

out went the coaches and in came a spacious ballroom and the complex became known as the Winter Gardens Theatre/Cinema and Ballroom. It was a massive building much taller than any other building in the town. Ronald Ashworth of Rhos was responsible for the building, to the design of local architect Arthur Hewitt. James Yates, father of the famous television personality Jess Yates, supplied the electrical installation. The interior design was Art Deco and a Christie Electric Organ rose majestically out of the floor, glowing with multi-coloured lights, to the delight of audiences. Seating nearly 2,000, it was equipped for both live stage and film performances. Opened in March 1935 Gracie Fields, who by then was better known as a film star than a singer, gave a live telephone message of good wishes, which was relayed to the audience through the speaker system.

After only eighteen months the venture was losing money so the Brierleys decided to sell the cinema to Oscar Deutsch, who duly renamed it the Odeon (Oscar Deutsch Entertains Our Nation). The Welsh National Opera was an annual visitor to the cinema/theatre, but probably its most famous live performers were the Beatles in August 1963, at the start of Beatlemania. The complex closed in 1986 and was demolished in 1989.

Reginald Foorte's Portable Moller Organ

Reginald Foort was the resident organist at the BBC in London before the Second World War. Deciding to go freelance, in 1938 he commissioned the Moller Company of America to build him a portable theatre organ. 'Portable' was a relative description as it weighed 20 tons and needed five pantechnicons to transport it to theatres around the country!

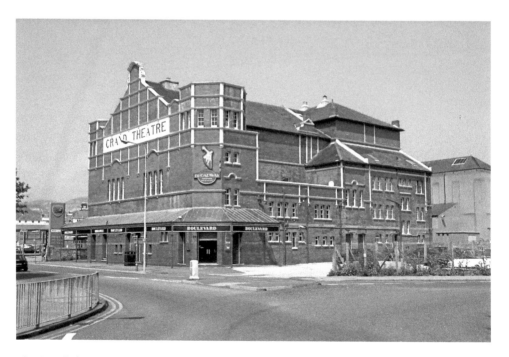

The Grand Theatre.

Boasting 2,000 pipes with 300 stops plus numerous bells and whistles, it used a 32 hp electric blower to provide the air pressure. After a performance his team of thirty men had to take it apart for removal to the next venue. On the side of each van was the inscription 'Reginald Foort's Gigantic Organ'!

The BBC organ Foort had played was damaged in bombing during the Second World War, so he offered his portable organ to the BBC. Initially, it was installed in the Grand Theatre, Llandudno, and regularly used for broadcasts. In fact there was not much else on the radio in those turbulent early years of the war. Later, when the threat of German bombing receded, it was moved to the BBC's Penrhyn Hall at Bangor.

After the war it was sold to Radio Nederland and after many years at Hilversum found its way, via several owners, to the Pasadena Civic Auditorium, California, where, fully restored, it is still a popular attraction and can be seen and heard on YouTube.

Organist Reginald Foorte.

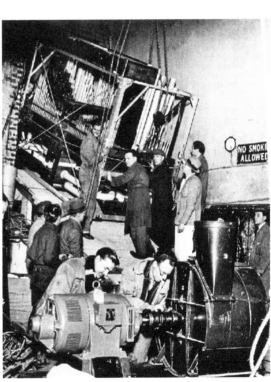

Reginald Foorte's Moller Organ being installed in the Grand Theatre during the Second World War.

10. First World War

Mametz

In 1914 the first (North Wales) brigade was raised in Llandudno. In 1915 there was a big St David's Day Parade which Lloyd George, as Chancellor of the Exchequer, attended. Thousands watched as Lloyd George proclaimed it 'one of the most magnificent spectacles I have ever seen'. In 1916 the Llandudno Brigade on the Somme was eventually ordered to take Mametz Wood. In the two-day massacre, 4,000 men were killed or wounded. It was a totally futile attack because the Germans were too well entrenched for it to have been successful. There is no mention of Mametz in the official battles of the First World War and no matching battle honours. The village of Mametz had been totally destroyed by shelling, so in 1920 the people of Llandudno adopted it. Survivors of the Llandudno Brigade were among those who contributed to a Llandudno fund to help restore the French village. However, veterans and descendants had to wait until 1987, on the seventy-first anniversary of the battle, before a proper memorial was erected on the ridge where they had run into the jaws of the hidden enemy's machine guns. The people of Mametz had long since named the ground 'Vallee des Gallois' in honour of the Welshmen who had died there.

The memorial to the fallen at Mametz Wood on the Somme in 1916.

Escaped German Prisoners

On the night of 13 August 1915, three German prisoners, having retrieved their civilian clothes from under the floorboards where they had hidden them, forced the bars on the windows at Dyffryn Aled Prisoner of War Camp, Llansannan, near Denbigh – which was essentially just a country house. They were confident they would not be missed until roll call the following morning and walked 20 miles to Llandudno, enjoying a meal in a café before going into hiding for the day.

At dusk on the 14th they left their hideout and tried to scramble down the rocks below the lighthouse. In the darkness the submarines moved towards them, waiting for a signal which never came, because the men failed to reach the beach. The arrangement was that the submarines would come for three consecutive nights and the next night the escaped prisoners actually reached the beach, but failed to rendezvous due to their sight of the sub being obscured by rocks.

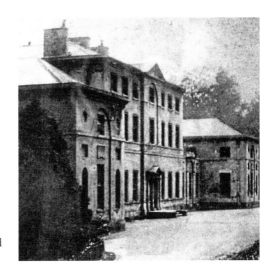

Right: Dyffryn Aled, Llansannan: the camp where the Germans were prisoners.

Below: The area below the lighthouse where the three escaped prisoners were to be picked up by submarine.

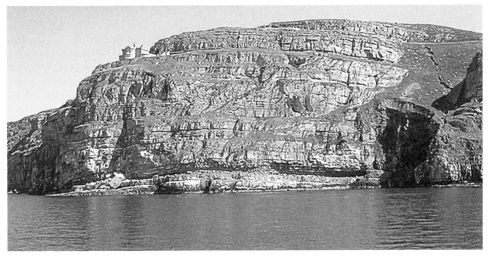

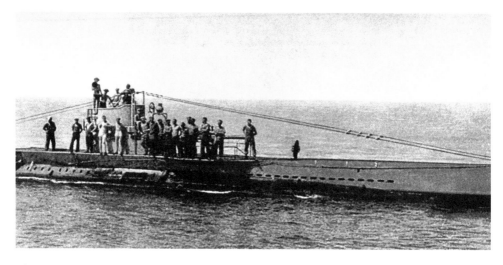

The German submarine U38, which tried to pick up the prisoners.

After three nights they wrongly thought their rescuers had not come and that's when, tired and hungry, they returned to Llandudno with the objective of making their way to London by train.

Shortly before 9 a.m. on the 16th a man entered Herbert's Tobacconists in Mostyn Street and his accent immediately aroused Mr Herbert's suspicions, bearing in mind that the whole of North Wales was on high alert for three German POW escapees. Mr Herbert voiced his suspicions to a milkman who was in the shop at the time and asked him, in Welsh, to follow the stranger until he found either a policeman or a soldier. Soon afterwards the stranger was arrested by Constable Morris Williams.

A cab man came across the other two POW's in Prince Edward Square and drove them to the HQ of the London Welsh Battalion, rather than to the station, where they'd intended to catch the 9.15 p.m. train to London. They apparently had the names and addresses of people who would shelter them in the capital.

In September the three German POW's were tried by court-martial at Chester Castle and sentenced to eighty-four days' imprisonment at Chelmsford Prison without hard labour.

DID YOU KNOW?

At the outbreak of the First World War, the Town Council took out an insurance on all public buildings. In 1916, following German air raids in the south of England, the council ordered that all street gas and electric lamps should be unlit except where needed for public safety. Local shopkeepers were requested to shield their shop lamps. At the same time, the General Post Office reduced their daily deliveries of mail from four to twice daily.

The Arnold Brothers

At the outbreak of the First World War, Britain's army was small and Kitchener, the Minister for War, started a campaign to recruit more men. A Recruiting Centre was established in Payne's Majestic Ballroom and by November 1914 Llandudno had become the headquarters of the newly formed North Wales Brigade. Soon the 13th, 14th, 16th and 17th Welch Fusiliers and the 15th Royal Welch were all billeted in Llandudno.

The hotels and boarding houses, which had been hit by cancelled holidays, were now paid to billet the troops. During the war more than 7,000 wounded soldiers were nursed back to health in the numerous local hotels and convalescent homes.

William Arnold, a Norfolk grocer, came to Llandudno in 1882 and set up a family drapery business in Mostyn Street. His sons, William, Arthur, Clem and Frank were born here and destined to become war heroes. The four brothers were tank commanders and all were decorated for bravery. All were injured but eventually returned home safely.

By 1916 all the soldiers billeted in Llandudno had left for the front. In September 1916 at the Battle of Flers-Courcelette, Arthur in his tank – which he called 'Dracula' – made a successful incursion through enemy lines. Despite being wounded in the knee, he went to the assistance of another tank and rescued a wounded man. He brought his tank back safely and was awarded the Military Cross. He was evacuated back to the United Kingdom due to his wounds but eventually recovered and rejoined the Tank Corps in 1917. During an attack near St Julien he was shot through the lung and taken as prisoner.

Despite being seriously injured at the Battle of Loos, William was awarded the DSO; Frank, wounded at the Battle of Hooge, was awarded the Military Cross.

By November 1917 the Battle of Passchendaele had been the last battle in the old style, with a list of casualties almost as bad as that on the Somme. Tanks had been tried but proved to be useless in the muddy fields of Flanders, but the Tank Corps saw more hope with the dry hard ground of Cambrai, some 45 miles south of Ypres.

A model of the 'Whippet' Light Tank, which Colonel Arnold commanded at the Battle of Cambrai.

Colonel Clem Arnold with the German officer who captured him and became his lifelong friend.

On 20 November 381 tanks moved forward in mass formation. It was a rout. They crossed the three German lines, advancing 5 miles on a 4-mile front. Lt-Col. Clem Arnold was in the vanguard of the charge in his new Whippet light tank, which he named 'The Musical Box'. The Germans were completely overwhelmed even though, as we now know, they had been expecting the attack. A greater success was achieved than that on the Somme or at Flanders. Clem's tank was hit and burst into flames. He was able to pull his two crewmembers out but one of them died. Clem was taken prisoner and during this time was reunited with his brother William. There were 1,500 British casualties against 10,000 German prisoners and 200 guns captured. Bells were rung across Britain for the first time in the war, to celebrate the victory. The infantry had not been able to keep up with the tanks and the cavalry were cut to pieces by German machine guns. Within ten days the Germans had reinforced and retaken all their lost ground. Clem Arnold, who was awarded the DSO, was befriended by his captor and they remained lifelong friends. This action was described as 'surely the most remarkable individual tank action of the whole war. One light tank...fought its way through countless odds and faced the rear of the German army single-handed.'

In 1920 a tank which had fought at Cambrai was given to Llandudno. Clem Arnold, with a five-man crew, drove it through the town (there is *Pathé News* footage of this) to its final resting place on display on Marine Drive.

Clem helped to run the family business but at the outbreak of the Second World War he joined the local TA Unit, becoming Commanding Officer of the 69th Medium Regiment, Royal Artillery. After the war he came back to run the shop and was a well-known local character. He died in 1978.

Airship Repair

In 1918 an excited crowd gathered on the Promenade while a broken-down airship was being repaired. A Royal Naval Airship Station had opened in Anglesey in autumn 1915. The airships protected merchant ships in the Irish Sea from German submarines. On 26 April 1918, an airship with a crew of three took off from Llangefni, tasked with searching for a German submarine which had been seen near the Formby Lightship. After several hours the engine seized and the onboard engineer was unable to restart it. As the craft drifted towards the North Wales coast, its Mayday distress message was picked up by an armed trawler, which came to its aid and towed it to Llandudno.

A platoon of soldiers lodging in the town at the time was summoned to the end of the pier and took over the tow rope from the trawler. The soldiers walked the stricken airship, which was still airborne, to the Promenade and tethered it close to The Hydro Hotel. Members of the public flocked there to see the huge silver balloon at such close quarters. The police roped off the area and warned people about the dangers of smoking in the vicinity of the hydrogen-filled airship!

The pilot was invited to take a bath and a meal at The Hydro Hotel, but when dressing found that he had no tie to wear for dinner. He was lent one by the hotel manager, but later recalled that it was 'very gaudy for a Naval Officer, and caused considerable amusement'.

In the meantime, mechanics had arrived from Llangefni to fix and inflate the balloon's envelope. Later in the evening the craft took off from 'between two lamp standards' for the flight back to Anglesey.

A Royal Naval airship at Llandudno.

11. Second World War

Royal Artillery Coast Artillery School

In 1940, during the first few months of the Second World War, the government decided that with the threat of Nazi invasion and bombing, the Royal Artillery 's Coastal Artillery School should be relocated from Shoeburyness to somewhere safer. After much searching, an area of the Great Orme at the end of Llys Helyg Drive was chosen. The site was considered to be ideal both for the location and the wide estuary with safe anchorage for the target vessels. By September 1940 the move was completed and training had begun.

In addition to the Gunnery Wing, a Searchlight Wing and Wireless Wing were established. In April 1941 the first Wireless courses had begun for training in Radio Location and Radar. A practice battery was built in the quarry on the Little Orme, which was used for training and also as part of the coastal defences.

By 1942 there were 150 officers, 115 cadets and 445 other ranks at the school, which was able to run fourteen courses at a time. The personnel were mostly accommodated in local hotels and boarding houses. The same year, Llandudno Home Guard were trained on 6-inch and 12-pounder guns and with searchlights, and in 1943 they were officially named as the Coast Artillery Battery, Home Guard.

By 1946 the site had been vacated and in the 1950s most of the buildings were demolished, though about six of the searchlight installations and the power station still exist.

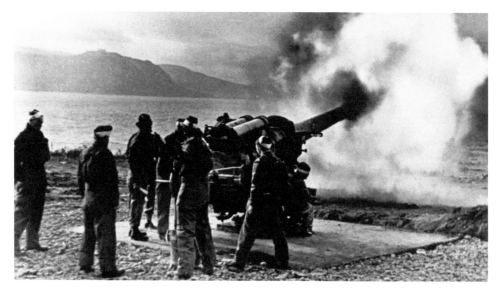

Training on the big 12-pounder gun at the Llys Helyg Artillery School.

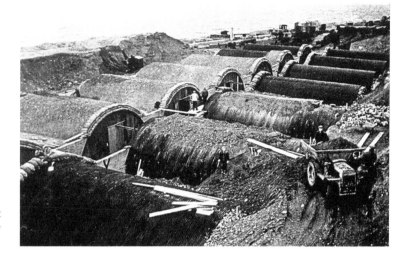

The construction of the magazine at the Coast Artillery School in 1940.

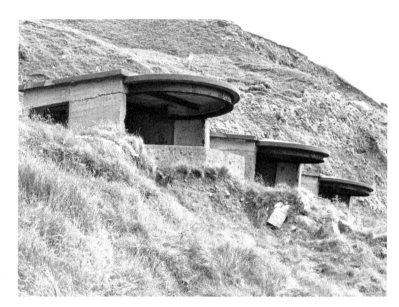

Some of the remaining searchlight installations at the Artillery School.

DID YOU KNOW?

As early as 1938, plans were being put in place to provide air-raid shelters for the people of Llandudno for the expected German bomber raids. It was proposed that Elephant's Cave, one of the largest of the caverns left as a result of Victorian era quarrying in the Happy Valley, should be used. It was soon realised that getting any number of the populace up there might not be practical, so several brick-public shelters were eventually built in the town.

Home Guard

On the evening of 14 May 1940, the Minister of War, Anthony Eden, broadcast a wireless message asking for volunteers for a new defence organisation to be known as the Local Defence Volunteers (Winston Churchill changed the name to the Home Guard in August 1940). It was formed when the risk of German invasion was at its highest and was intended for men who were either too young or too old to join the regular army, or in reserved occupations.

In Llandudno, men were to register for the LDV at the police station and within minutes Jack Owen, a Crosville bus driver, was the first to enrol. By the end of the first week 414 local men had volunteered, 100 of those being civil servants from the Inland Revenue who had been sent from London to Llandudno for the duration of the war.

On 31 May 1940 the volunteers gathered at the Town Hall in the evening to parade and then go out on all-night patrols around the local area for the first time. The men were organised into four companies: 'A' Company patrolled the Great Orme, 'B' Company the West Shore, 'C' Company Craig-y-Don and 'D' Company Penrhynside. Lt-Col W.H. Lester became the Commanding Officer of the 5th Battalion (Caernarfonshire) Home Guard, and Battalion Headquarters were established at the Irish Linen Warehouse in St George's Place.

They were an extremely well-organised and efficient Home Guard, the envy of many other units – 'Dad's Army' they certainly weren't! They built a practice rifle and machine gun range as well as an assault course at Maesdu Farm, while also having a pigeon loft at their HQ in case other communication links failed.

Between June 1940 and December 1944, when the Home Guard stood down, the men patrolled the local coast and countryside nightly and also took part in two twenty-four-hour

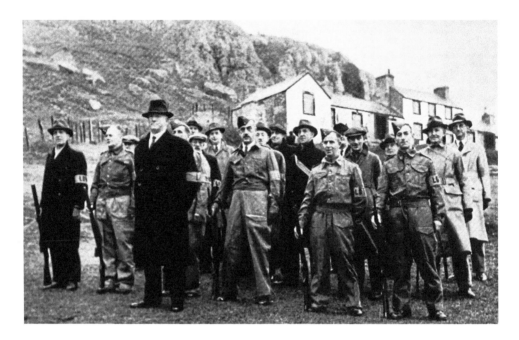

The Llandudno Home Guard Company prepares to mount an all-night patrol of the Great Orme.

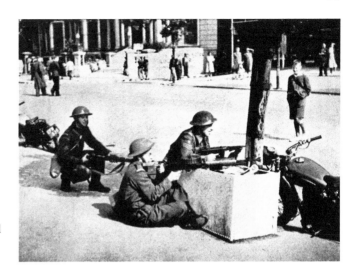

The Llandudno Home Guard
Unit on exercise in
St George's Place.

exercises: 'Whitsun' in the summer of 1941 and 'Pippin' in April 1942. On both occasions they were joint exercises with Civil Defence organisations and were designed to see how they would respond to an air attack or invasion by parachutists, or seaborne troops. The Home Guard patrols scoured the town for 'enemy' combatants and set up roadblocks to stop motorists and check identity cards. The 'enemy' were soldiers from the Royal Corps of Signals and those caught were taken to the Town Hall for interrogation.

Members of the Home Guard were a familiar sight throughout the town during the war and took part in many parades such as 'Salute the Soldier', 'Warship Week' and 'Wings for Victory'. They often had social gatherings at the Swiss Café, consisting of a hotpot dinner followed by entertainment provided by their own members.

DID YOU KNOW?

Llandudno has only had one aircraft crash and that was in the summer of 1943. A young pilot flying solo in an Airspeed Oxford was giving an air show for his girlfriend, who was a maid at the Craigside Hydro Hotel. While she watched him fly along the Promenade towards Craigside, he miss-judged and crashed straight into the cliffs of the Little Orme. She was comforted by the wife of the owner of the hotel, Mr Joseph Kendal Jackson.

Secret Agents

At the start of the Second World War plans were made, in the event of a German invasion, for German agents now working for the British to be hidden in hotels in North Wales. The Evans Hotel and the White Heather Hotel in Llandudno were two of these.

The Evans Hotel was used to house double agents from 1941 to 1943.

In January 1941, these agents were regarded as a security risk by the British, and it was feared that they would pass on information to the Germans if captured.

Seven agents with their families were scheduled to check-in to these unlikely hiding places. One of the turned agents, Arthur Owens, was born in Wales and had been told by the Germans to recruit a Welsh Nationalist. He recruited Gwilym Williams but MI5 turned him too.

After Dunkirk, although the British had captured and were controlling all double agents in the United Kingdom, there were concerns they could switch sides in the event of invasion. In March 1941, a letter was sent to MI5's contact in North Wales to make arrangements for the safe custody of these individuals. An operation codenamed 'Mr Mills' Circus' was named after the senior MI5 officer in charge, Cyril Bertram Mills, whose family actually did run Bertram Mills Circus! It involved MI5's North Wales agent, Captain Finney, finding accommodation for the double agents, their families and armed minders.

As a result, arrangements were made for them to stay at hotels, including The Eagles in Llanrwst and The Swallow Falls in Betws-y-Coed. Within a few weeks Captain Finney told London he had completed arrangements for 'the animals, their young, and their keepers'.

The order was given that in the event of an invasion the agents and their families should be taken down into the basement and summarily executed. Two years later the plans were scrapped as the tide of war had changed and the possibility of invasion receded. And I bet everyone gave a big sigh of relief!

About the Author

I first set pen to paper, as it were, at boarding school when, aged ten, I produced a school newspaper. It was there that I also gained my interest in photography and film-making, though not strictly part of the curriculum.

After a varied career, which included three and half years in the RAF, I eventually turned to photography and film-making as a livelihood, spending thirty-seven years as a news cameraman with BBC Wales and twice winning awards from the Royal Television Society for my work.

In around 1973 I joined the Llandudno Civic Society, then run by that great conservationist the late Stuart Rivers. We saved St John's Church in Mostyn Street from demolition and restored the historic St George's Old School in Church Walks to full use for the Education Department of Conwy County Council. We have put on many exhibitions in the town to promote Llandudno's history and importance as a holiday resort.

I am chairman of Llandudno and Colwyn Bay History Society and a trustee of Llandudno Museum.

I am the author of three books and I also write a monthly opinion column in the *Weekly News*. Today I seem to spend more time in front of the camera as a tame local historian than behind it!

By the same author
Llandudno History Tour
Llandudno Through Time (co-authored with Christopher Draper)
Scandal at Congo House (co-authored with Christopher Draper)

Bibliography

Draper, Christoper *Llandudno before the Hotels* (2007)

Gwalchmai, *The Llandudno Handbook or Visitors New Guide* (1855)

Hiller, George *Your Obedient Servant* (2003)

Wynne Jones, Ivor *Llandudno Queen of Welsh Resorts* (2002)

Wynne Jones, Ivor *Shipwrecks of North Wales* (1973)

Rowlands, T. *Recollections of Llandudno (Llandudno Advertiser* 1892)

Williams, F. Ron *Llandudno and the Mostyn Influence* (1996)

Williams, F. Ron *Llandudno and the Mostyn Influence 1861-1939* (2002)